PAINTING AND
UNDERSTANDING
ABSTRACT ART

KU-014-337

ACC. No: 03109530

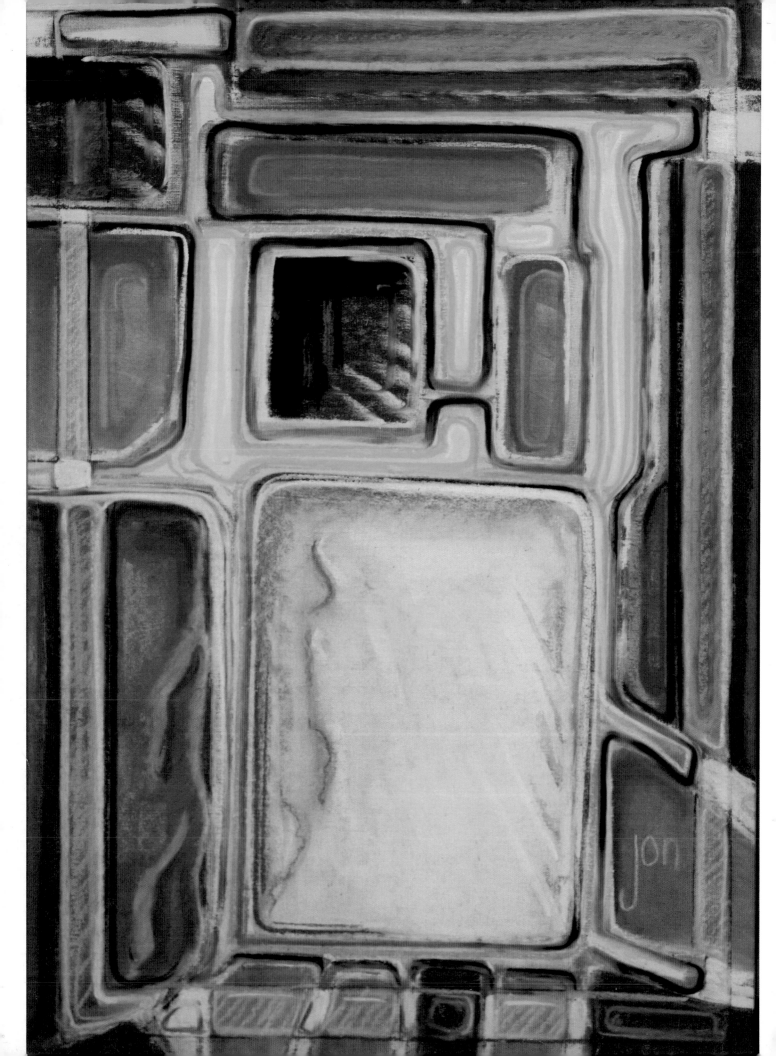

PAINTING AND UNDERSTANDING ABSTRACT ART

JOHN LOWRY

Cardiff Libraries
www.cardiff.gov.uk/libraries

Llyfrgelloedd Caerdydd
www.caerdydd.gov.uk/llyfrgelloedd

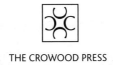

THE CROWOOD PRESS

First published in 2010 by
The Crowood Press Ltd
Ramsbury, Marlborough
Wiltshire SN8 2HR

www.crowood.com

This impression 2012

© John Lowry 2010

All rights reserved. No part of this publication may be reproduced or
transmitted in any form or by any means, electronic or mechanical,
including photocopy, recording, or any information storage and
retrieval system, without permission in writing from the publishers.

British Library Cataloguing-in-Publication Data
A catalogue record for this book is available from the British Library.

ISBN 978 1 84797 171 5

Frontispiece: *'Spangles'*

Acknowledgements

This book would not have come about without the help of my brother,
Duncan. Images are crucial to the understanding of the messages within
the book and he has been involved in the presentation of all of them.
Of particular importance are his presentations of my ideas within the
colour section, which have impressed me greatly.

I must also acknowledge the input of the Rev. Dr Nicholas Buxton, who,
under the last-minute pressure of the publisher's deadlines, offered an
overview that helped to tighten up presentation – any flaws are mine.

All paintings, illustrations and sketches in this book are by the author.

Typeset by Servis Filmsetting Ltd, Stockport, Cheshire
Printed and bound in India by Replika Press Pvt Ltd

CONTENTS

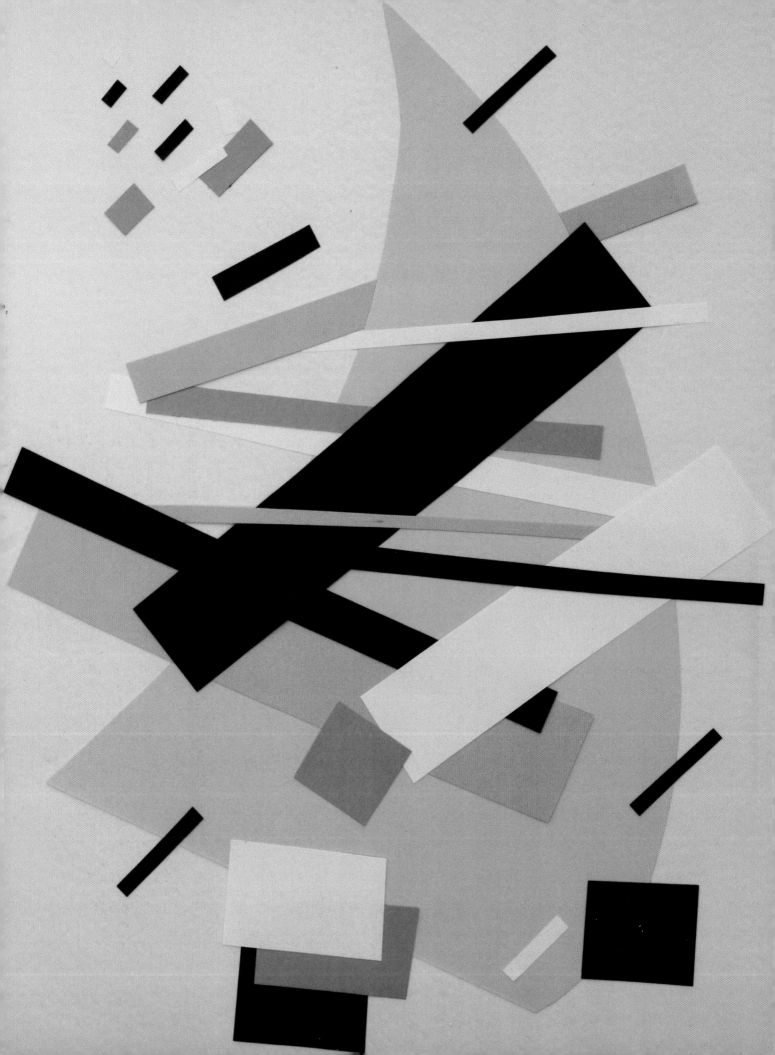

PREFACE

This is a book for thinking painters, whether new to art or experienced professionals. It is essentially a practical painting book but since abstract painting is as much a thinking process as it is a 'doing' process, effort is made to help our understanding and our ability to analyse what we are doing, why we are doing it and what to do next. Until pennies drop it is always difficult to move to the next stage of understanding. By using practical exercises along with the explanatory text it is hoped that the thinking and the doing processes can develop in tandem.

This is not just a book about painting abstracts; it is a book about understanding painting and about understanding art in general.

Perhaps the most difficult stage in painting abstracts is getting started. We have all seen abstract paintings, but if asked to paint an abstract, we usually have no idea how to begin. The approach here is to move progressively from our comfort zone of figurative painting (where the subject is still clear) toward abstraction, but in mentally acceptable stages. Most of the images discussed in this book do not reach complete abstraction, but hover somewhere between the realistic and abstract extremes. I do not argue here that there is any merit in an artist making all his images completely abstract as there is a lot of satisfaction to be found in working in the middle ground.

A simple change in mindset is needed to start the journey into abstraction. A move away from the need to copy and toward the understanding that the artist is in charge of what he paints is fundamental to this approach. Try to believe that what is in front of you is only the starting point. Items can be moved and colours and shapes changed. Negative shapes can be made more important than whatever it is that encloses them. Straight lines can be changed to curves. A calm spring sunny day can become a dull, windy autumn day. A sunny scene can be turned into a moonlit one. The dull can be made bright. Backgrounds can be changed to harmonize with the main subject.

This book will identify the tools that are available to help, and we will apply them in simple combinations, experimenting to find pleasing end results.

Persistence is also an important factor in the early stages of mindset changing: don't give up too easily. No one promises that moving into abstraction will be easy, but most find the switch in approach to be enlightening and stimulating.

Realistic paintings and abstract paintings are not opposites, nor are they in any conflict or competition. In fact, artistic 'rules' such as composition, visual harmony, balance of shapes and colour, and the use of form and texture, are common to both. There is a seamless sweep between the two.

The first five chapters of this book are aimed at improving our understanding of what art, and particularly abstract art, is about. By the final chapter we will be in a position to examine the lives and times of certain artists who were involved in the stage-by-stage evolution from realism to abstraction and to try to analyse the mental processes of the time so that we can add these lessons to our own painting practice.

The author accepts that a great number of important contributors to the evolution of abstract art are not acknowledged in this book. This is either due to the limits on the scope of the book, which was never intended to be exhaustive, or to the limits of the knowledge and research of the author.

OPPOSITE PAGE:
A collage in the style of Kazimir Malevich.

AN INTRODUCTION TO ABSTRACT PAINTING

Abstraction is the opposite of copying. It is the use of the imagination to produce an image. It is not the opposite of figurative or representative painting, as the source of the subject of the painting can often be recognized without it being truly realistic.

Abstraction is a mental process involving either depicting what is in front of us, but in our own way, or realizing images directly from the imagination.

Often it is easiest to start with something realistic and to take it on a journey of simplification or exaggeration, and we can stop when the source can still be recognized or we can move on into complete abstraction where the source is unrecognizable. There are other approaches, but this one serves to aid initial understanding.

THE STAGES OF ABSTRACTION

1. Realistic

Realistic painting involves the creation of an image made to represent the subject as closely as possible to the way most of us see it. One could claim it to be almost 'photographic art', although perfectionists will point out that photography suffers from chemical and optical limitations and aberrations that prevent photographs from being truly representational. Realism was the norm for Western art certainly from the Renaissance period until the mid-to-late1800s, although art had never stopped evolving before this period – or indeed after.

2. Abstract-like

Think of the visual puzzles we were given as children where we had to work out what something was, having been drawn or photographed from an unusual angle (a cork-screw taken

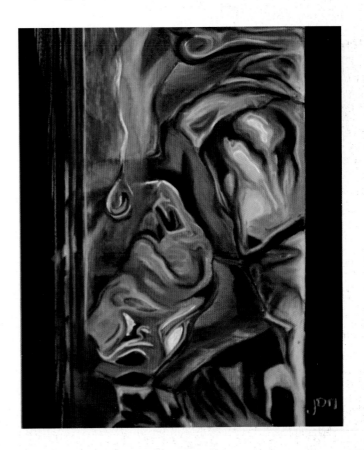

A painting of ice cubes in a whisky glass.

OPPOSITE PAGE:
An abstract-like painting showing reflections in stainless steel cladding on a New York building.

from the pointed end, for example). Or think of the images offered here of a New York street distorted by reflections in stainless steel wall cladding and of a close-up of ice cubes in a whisky glass. Both look unrealistic and could be categorized as abstract but in fact are very representational. This typifies the abstract-like category.

Already we are realizing that realism versus abstraction pigeon-holing is not clear-cut.

3. Realistic but made up of abstract components

This category includes, for example, English sixteenth- and seventeenth-century watercolours, which from a distance are very realistic but from close-up are seen to be made up of very abstract marks. If examined with a magnifying glass probably all paintings fall into this category, but it is a pigeonhole that is worth consideration.

A close-up of a section of an ink drawing showing abstract components.

Step back and you will see the image is a figurative drawing of a poppy flower.

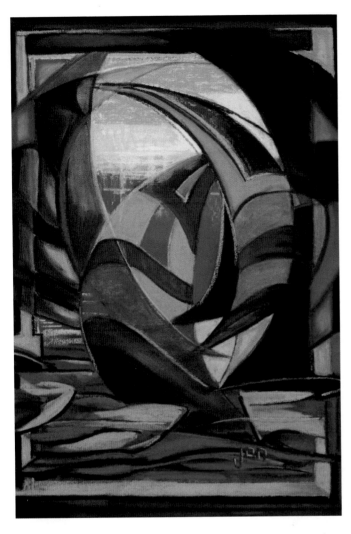

An abstracted painting. Whilst the source can still be seen, it is far from realistic.

A painting from within the abstract category. The source is not identifiable and the image is to be viewed in its own right.

4. Abstracted (still figurative)

Images within this category still show resemblance to the source subject so can be termed figurative, but the artist has changed something, perhaps by simplification, or by exaggeration, although the image can be seen to be the artist's own interpretation. This category can cover the clearly recognizable to the recognizable only when we see the title that offers a clue. Most early art falls within this category, as does any image that is not realistic but can still reveal its source whether stylized by the will of the artist or by the dicta of society.

5. Abstract (no longer figurative)

At this stage we have lost all contact with the source material. The work looks like nothing that is recognizable. It is a composition of shapes, lines and colours, which are pleasing to whatever degree, and is offering itself for judgement on this basis. Brought about through a process of evolution over the early 1900s, there is now a general acceptance that a good composition need not bear any relationship to the figurative.

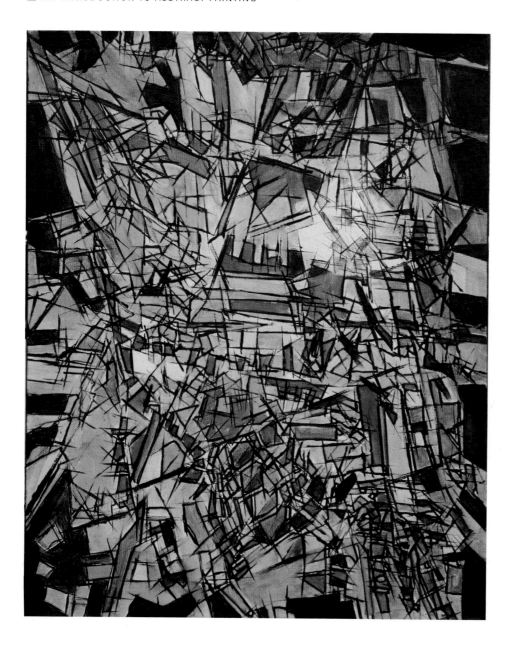

When viewing a complex abstract painting, one can often perceive some of the components together so that they look like something figurative.

6. Abstract seeing-in

An abstract painting can reach a level of complexity that engages the human brain in 'seeing-in', which involves imagining that some of the shapes together 'look like' something. It is as if the brain tries to create order and understanding out of confusion.

A BASIC UNDERSTANDING OF THE EVOLUTION OF ART

Art has not evolved in an isolated 'art bubble'. It has been influenced throughout time by the sociology, philosophy, religion, politics, understanding of science and technology, and of course the fashion, of its time and place. The outcomes of wars have had an enormous influence on art. Art is a part of our humanity. Art is not an island and its boundaries are under constant attack by the need for something new and different. All of the arts, whether visual or aural, are driven by this same need – the need for change.

Changing the mindset

The abstract artist must decide that he or she can paint in any medium or combination of compatible media, and can produce an image that may or may not look like something, in any style the imagination prefers. The imagination should predominate

over the need to copy and to paint realistically. There are no rules. There may be methods that work better for one individual than for others, but, in general, it is best not to feel that there are constraints.

Envisaging a subject or emotion in a different way in order to produce a pleasing image is so much more satisfying than painting every whisker on the cat or matching exactly the colour of that apple. Which is not to say that it is not much more exhausting than painting in a realistic fashion – indeed the thought processes involved can be a great drain on energy.

Nor does it mean that anything goes. The 'anything goes' attitude leads to blockages such as 'Where do I start?' and 'What do I do next?' because without structure, guidelines and logical stages for progression, painting becomes more difficult.

Is abstract painting modern art?

As this book is about abstract art, this is an obvious question. Without having established a firm definition as to what represents either ancient or modern art we are bound to say 'well, yes and no' as it can fall into both categories. The oldest recorded man-made marks are not representational, they are symbolic or stylized, and so it can be argued that they are abstract art. These early images range from hundreds of thousands of years ago to tens of thousands of years ago. It may be said that we started as abstractors and were drawn closer toward realism in the West before moving back into abstraction more recently. Abstract art is therefore the first and most ancient art.

By looking back to the oldest recorded images and paying respect to the art of the world's ancient pre-historically established ethnic nations – from North American pictograms, Aboriginal art, Eastern art and African art to the art of the

A sketch of a petroglyph from India dated at between 300,000 and 700,000 years old.

ancient Egyptians – we can observe that humans started with abstraction and lived happily with abstraction for hundreds of thousands of years before the Renaissance and Western art world insisted on realism.

A sketch of the Blombos Cave image of the Southern Cape, thought to be 70,000 years old.

A sketch of England's oldest art at Cresswell Crags, thought to be 30,000 years old.

It can be argued that abstraction, through history, has been the norm and that realism in painting only became accepted throughout the last few hundred years. Whilst many ethnic groups seemed happy to stick with their traditional approach, Western art developed very rapidly, passing into skilful copying, a stylized representation of status, and then back into the painting of ordinary people by the mid-1850s.

By then the photographic camera, which could create a realistic record, was in general use. This gave the artist his freedom to think once again and to free himself from the constraints of painting likenesses. The need to 'paint what's there' was re-thought.

The Impressionists took the first step in returning to abstraction. Building on this, there was a powerful movement away from the realistic that appears to have lost no momentum. This most recent phase of abstraction therefore has to be part of modern art.

There is a definite observable evolutionary trend from the mid-nineteenth century, and particularly into the first two decades of the 1900s, towards modern abstraction. This is the period upon which we are concentrating here, without any wish to detract from what went on before or after.

The importance of the medium

Many teachers of art make much of their favourite medium. Techniques and 'paint like me' can become all important. This is difficult to support, as art is art – no matter what the medium – and has little to do with directly copying someone else's approach.

Similarly, writing is writing, no matter the medium on which or in which it appears. All painting media have their own pros and cons and we use them according to preference or our mood at the time. To pretend that art itself is in the medium, in the tools we use (brush, palette knife, pencil, felt-tip pen) or the substrate (what we paint on), is misleading.

Of course, our chosen medium does affect the end product, but let us follow the writing analogy to illustrate the point. Do writers boast of being ball-point pen writers, or outdoors fountain pen writers or digital text writers on vellum? What difference does it make what we write with, where we write, or on which substance we write? Writers are judged on results, on how well they communicate.

Artists, on the other hand, are encouraged to buy an expensive special brush if they are to be successful. They are

pigeon-holed into art courses according to medium and/ or subject: 'Acrylics for improvers'; 'Wet-in-wet landscapes'; 'Portraits in oils'. We have all seen such courses advertised, but they put a misleading slant on what art is about. Such courses probably tell us more about the limitations of the teachers than what the teaching of art requires. Few, outside of universities and art colleges, have considered what they are doing and why they are painting.

Yet artists, just like writers, are communicating. Indeed, a good image can take the viewer beyond language (just as music can affect the listener) and move us directly to emotion without any words.

Everything expressed in this book applies to any medium. The application of pigment may vary, but the principles are the same.

THE COMPONENTS OF A PICTURE

Now let us examine the building blocks of art and the tools available to build up an abstract painting.

An extract from a painting showing tonal contrast.

An extract from a painting showing contrasts in colour intensity, from brights to neutrals.

Some paintings are a record of what the artist sees, some are a free or stylized interpretation of what he sees or visualizes, and some lose all reference to the source material. Indeed, some start without a figurative base at all, but no matter what type of painting is to be created the basic building block is a shape. (Some argue that the basic unit is the mark, but some paintings have no marks. Marks give texture.) Shapes are defined by the following criteria:

▓ COLOUR – the variation of colour tones (lights to darks), chromatics (variations within the colour spectrum) and intensity (brightness to dullness).
▓ LINE – outlines around shapes. These can be wiggly lines, smooth lines, straight lines, curved lines, fat lines, thin lines, coloured lines, dotted lines and so on.
▓ EDGE – edges can be colour-to-colour or texture-to-texture or tone-to-tone but with no line between.
▓ TEXTURE – some shapes may have texture, others may appear flat.

An illustration of variation in chromatics.

▥ FOCUS AND BLUR – some shapes appear crisp and in focus and some have soft edges.

▥ SIZE – big shapes versus small shapes.

▥ FORM – the implication of shape. This could be rounded, angular, geometric, rising up, sinking down and so on.

Shapes, as defined in these ways, produce the overall composition and can create visual rhythm, balance, harmony, contrast, discord, symmetry and zonal hierarchy.

The handling of the components listed above, the subject matter and the overview of the whole can in turn create an atmosphere with a sense of place, time, season, or weather, for example – in other words, moods, feelings, memories and emotions stimulated in the viewer. The stimulation of nostalgic memories can be particularly important because these form direct links with the viewer.

The components can also be used to give emphasis to shapes, whether positive or negative, to draw attention to some areas, or to play down others, thus creating hierarchies within the picture. They can be used to put several layers of interest in the image – the obvious, the less obvious and the subtle.

The components can also be used to imply movement via directional dragging, blurring or multiple-imaging. Rhythms can be created through the image by repeating (but varying) shape, size, colour, tone, texture, and so on. The rhythms created through alternating light and dark, such as varying sunlight to shadow, are very pleasing to the eye, and as artists we should not underestimate their value in creating an attractive image.

We will examine the practical use of these basic components in Chapter 2, but there are other aspects of painting that are fundamental to the artist's mindset and which ought to be addressed by every serious artist early in his or her development.

A close-up of an ink drawing showing the
use of line.

Some parts of the image are in focus and others are blurred.

A shape against a shape with no line
between them.

Some shapes have flat colour, others have texture or motif.

Large shapes and small shapes.

Shapes can be used to imply a third dimension.

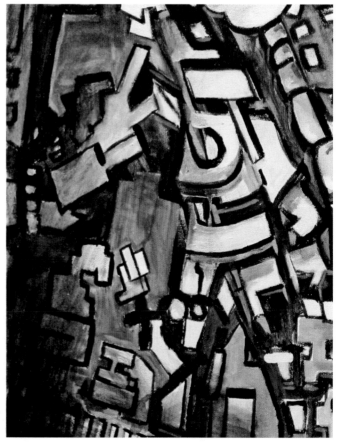

THE TOOLS FOR ABSTRACTION

Imagine having an artist's tool box that is full of tools that can be used individually but some work well in simple combinations. Here follow some suggested tools for the abstract artist along with a series of illustrated examples.

Simplification.

Simplification.

Exaggeration, for example colour.

The elimination of curves . . .

. . . or straight lines.

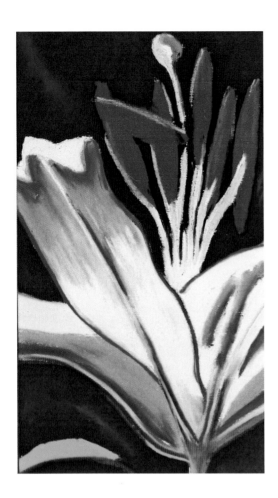

Close focus.

Outline.

The emphasis of positive or negative shapes.

Focus and blur.

Contrast in tones.

Contrast in intensities.

Texturing and mark-making.

Texturing and mark-making.

The texture of what we paint on.

The use of form.

Contouring.

Switches over lines or borders.

The use of zoning.

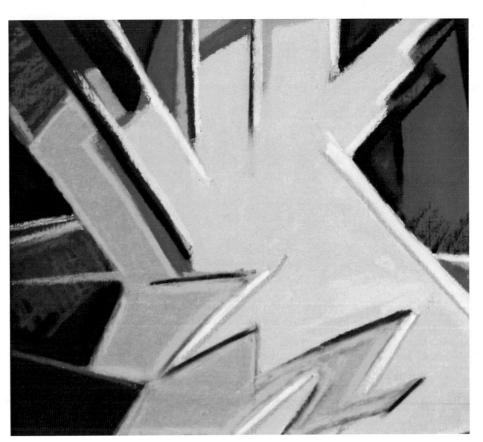

Flattening.

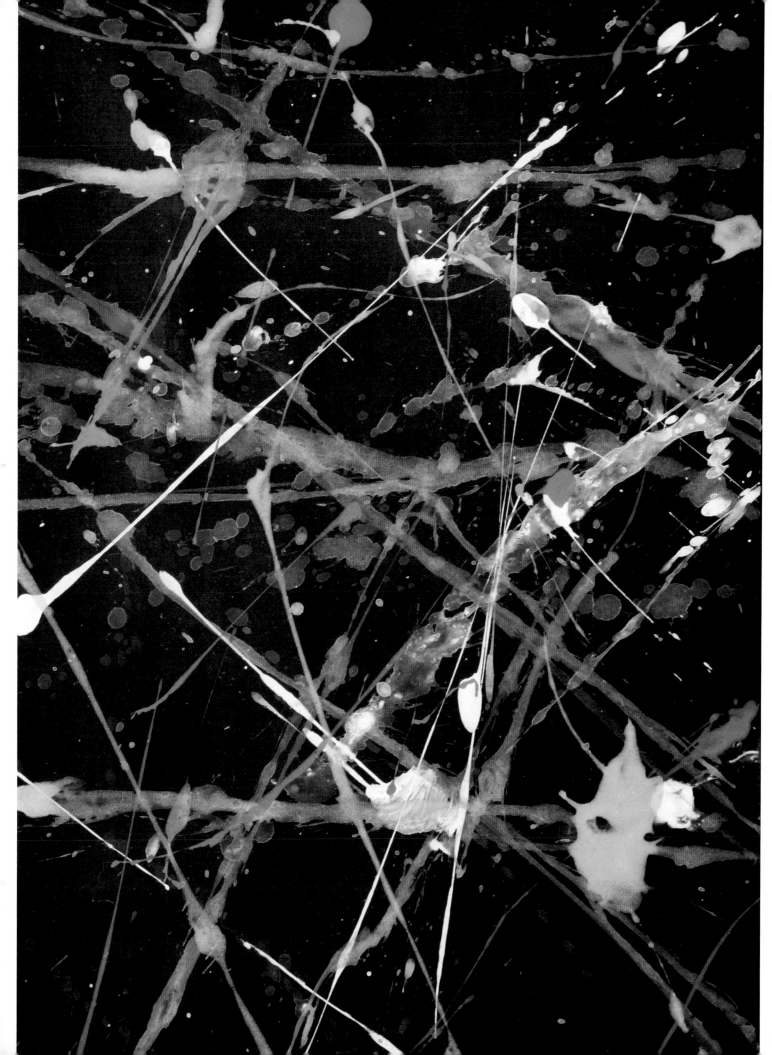

FROM THE REALISTIC TO THE ABSTRACTED – GETTING STARTED

The abstract is all around us and is so commonplace that often we do not even notice it.

A photograph of bark.

OPPOSITE PAGE:
Example of a splash image.

A photograph of peeling paint.

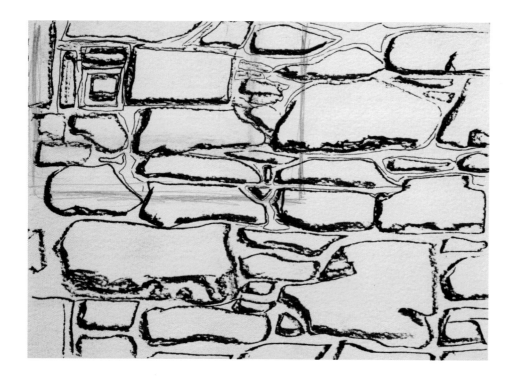

A sketch of a stone wall.

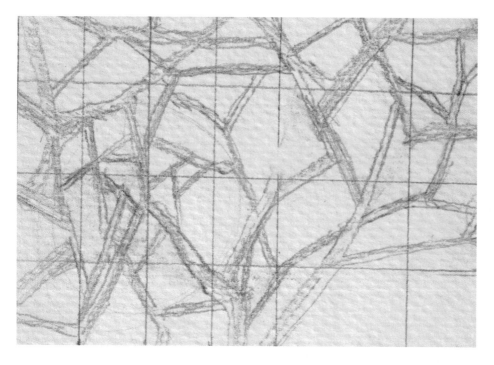

A sketch of crossing branches.

This chapter contains seven practical exercises to start us off, using odd viewpoints, examples from nature, scribbles and hieroglyphics and a bit of serendipity. The tools to be used will include close focus, outline, the elimination of curves and the use of bright colours. In four of the exercises we will start from the realistic and change things in a series of stages and another three will involve being free and easy to get an initial composition and then to build on the outcome.

PREPARATORY STAGES

When realism is the starting point it is essential to start with the sketch book and to begin filtering out elements of the subject and possibly bringing in others. At this stage err toward the simplification of the sketch.

Aim to sketch the subject simply, with little emphasis on form or texture. Just think of creating flat shapes. Draw lines around

Using 'L'-shaped cards to select the composition.

shapes, colours and tones, so that each is enclosed with a line and nothing drifts without being enclosed. This sounds simple but it involves a lot of decision-making as to where the line between a gradation of tones (for example) is to be drawn. Aim at getting an image something akin to a 'painting by numbers' starting point. Within each shape there will be one flat colour.

Composition

Use 'L' shapes to compose the picture in your sketch book. When satisfied with the composition, square off the boundaries to your square, rectangle, letterbox or oval.

Scaling-up

The scaling-up of your sketch is a crucial part of your preparation. Divide your sketch into halves, then quarters and then eighths. Similarly divide your final substrate – your canvas, board, paper, or abrasive paper – into halves, quarters and eighths.

The aim is to scale-up the sketch to the final substrate. But obviously there is a potential problem. What if you have decided that the best composition of your sketch is a square, but your canvas is rectangular? There are three ways out of this conundrum.

The first is always to be conscious when using the sketch to select your composition of the rough shape of your canvas and to select it to comply. If the canvas has proportions of three units by two units, for example, then try to select your initial composition to fit.

The second possibility is to ignore the differing proportions and to allow the resultant distortions to add to the abstraction. This can help in creating an interesting image by stretching or squashing.

The third option is to adjust the substrate to the sketch proportions. This is easy if it is paper and you can trim it, otherwise seek to fit the sketch within the canvas and allow the unused space to be your 'mount'.

Using the subdivisions you created earlier, transfer the lines from the sketch to the final substrate. Usually there is a need to get it more or less right, but do not get too hung up about accuracy. Nothing is cast in stone and adjustments can be made later, so relax.

Many artists hate this scaling-up stage and prefer to go straight to final substrate, missing out the sketch. This is fine, as it offers spontaneity, but it can create problems that will need to be resolved later. A composition that does not work is almost impossible to put right later, so it is better to resolve it early. All other aspects of a painting can be adjusted, but the composition needs to be sorted out first. The experienced can miss out initial stages, but otherwise, for the sake of the end product, please suffer them.

A square picture on a rectangular canvas. Let the 'spare' canvas function as a mount.

Your choice of medium and substrate

One other point that should be emphasized before we begin painting is your choice of medium and substrate. We all have our favourites, and abstracts can of course be painted in any medium on almost any surface. There are, however, differences in approach governed by the medium and due to the necessity to adjust and readjust as the painting develops.

Rarely can any of us get an abstract to work first time, so we have to accept that when we get one area to work well, the rest of the painting has to change if the whole is to be equally pleasing.

The different media have differing scope for change. Watercolour is probably the least open to change, so your approach has to accept from the start that there will be a progressing series of paintings culminating in the most pleasing. Move each stage as far as it will go, then move on to the next and start afresh, building on the previous stage. This has the advantage of leaving a record, stage by stage, of the thought processes as they evolved. Very experienced water-colourists argue that the medium is as flexible as any, or more than others, but the less experienced do not usually feel this way.

More opaque media such as gouache, acrylic and oil are a little more flexible in that you can over-paint – or scrape off and over-paint – to some degree, but it is fair to say that the colour underneath always has some influence on the superimposed colour, so again several separate stages may be involved as the painting evolves.

By far the most versatile medium, and the one that accommodates the need for constant adjustment best, is soft pastel on SAIT® abrasive 'paper' (the 'wet and dry' paper they use to rub down car paintwork during repairs). Soft pastel is ideal as it comes in hundreds of colours, so colour mixing becomes a subtlety rather than a fundamental chore. The SAIT substrate (it's not paper) is also ideal as it allows the pastel to be brushed off and over-painted as many times as you wish. It is as tough as old boots and can be used over and over again simply by rinsing it under water and rubbing it with a brush or cloth. The one downside of SAIT is that it lacks texture. Being flat, texture has to be applied, so the aesthetic benefits offered by textured papers or coarse canvas are not there.

Abstraction is not limited to the medium, but your preferred choice will involve its own particular approach and, of course, will contribute to the end result.

EXERCISE 1.

A Cabbage

CLOSE FOCUS, ELIMINATION OF CURVES, OUTLINE, BRIGHT COLOURS

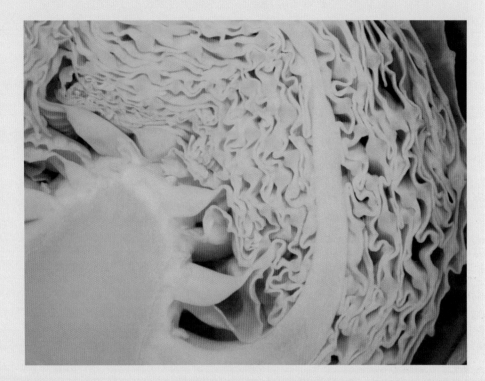

A photograph of part of a section through a cabbage.

1 Focus in closely to a section through a cabbage.
2 Sketch it as it is, in pencil. Alternatively put the chopped side on a photocopier and take a pale black and white copy. With a felt tipped pen outline the leaves.
3 Compose.
4 Scale-up.
5 Colour the layers in the cabbage in a series of bright colours, perhaps with a progression of colours from bottom to top, but leaving a gap between the colours to allow a substantial line between them.
6 Having established your colours, and if you are happy with them (if not, change them), select a colour for the outline that benefits them all. If you have selected many colours then your best option may be a black or a white outline.

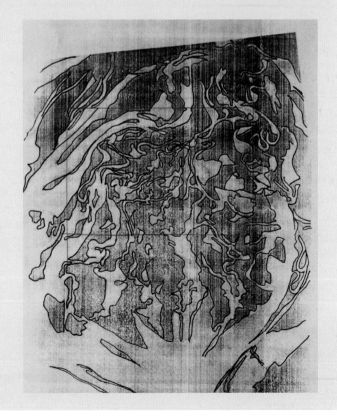

A photocopy of a section through a cabbage.

31

The resultant painting.

EXERCISE 2.

A Stone Wall

CLOSE FOCUS, BRIGHT COLOURS, THE ADDITION OF FORM

1 Sketch a section of irregular stone walling.
2 Compose.
3 Scale-up.
4 Add bright colours to the shapes, but apply the colour flatly.
5 Adjust the colours of the shapes so that the juxtapositions work well and the overall effect is pleasing.
6 If the stone shapes have mortar between them then leave a gap so that the mortar can be coloured later.
7 Once the colours and shapes are working, we can begin to think of adding some form to the shapes. We can make some shapes appear to come up, like a hill (a peak), or we can make some appear to go down into a hole (a trough). Start by deciding that the sun has come out – say, at the top right. Then consider each shape. If it is to be a peak, then the top right will be the lightest tone of the coloured shape and the bottom left will be the darkest tone. You just need to decide how light or how dark your tones should be and how high the peak should appear and the nature of its shape. Conversely, if a shape is to be a trough then light will hit it at the bottom left and the top right should appear in darker tones. Doodle with this concept with a pencil in your sketchbook before you begin your main canvas. Some peaks might have pointed tops, and some flat. Similarly, the troughs should have form.
8 Having created form on the shapes, consider what colour to apply to the 'mortar' or the space between the peaks and troughs.

Doodling on the sketch to experiment with peaks and troughs.

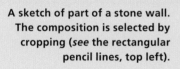

A sketch of part of a stone wall. The composition is selected by cropping (*see* the rectangular pencil lines, top left).

EXERCISE 3.

Crossed Branches

WORKING ON NEGATIVE SHAPES

1 Examine a tree in winter and without leaves. The branches split into smaller twigs toward the younger extremities. Use a camera to compose a series of images, attempting to capture a range of shapes enclosed by the branches. You are preferably looking for a composition with large shapes ranging to small.

2 Copy the bits you like to your sketchbook and select the most pleasing, with the best range of differing shapes.

3 Compose.

4 Scale-up.

5 Forget that some branches are in front of others, just look at the shapes between them. With a pale, neutral colour, lightly sketch in contours (as on a topographic map) within each shape. Using colours progressing from yellows through to golds and oranges to reds, colour in the various spaces between the contours.

6 If you feel the 'branches' need their own colour then apply it as a single colour.

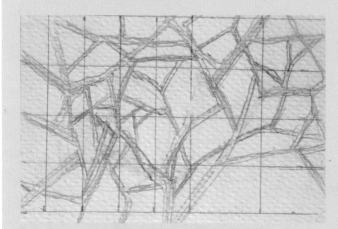

A sketch of the shapes formed by crossing branches.

7 Turn your painting around to see the orientation in which it looks best. Often the orientation in which you painted it is not its best.

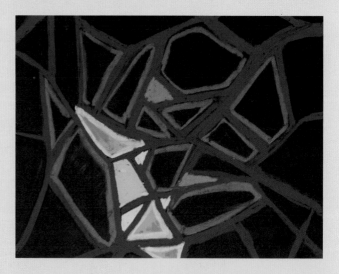

The end result.

'Starbursts' appear in this type of picture. This is where four or more lines come together at one spot. They tend to grab the eye and draw attention to areas of the image that don't need it. This problem is easily solved by moving some of the lines off the central point.

Once the starburst has been spotted, the problem can be solved by moving two or three of the lines away from the focal point.

EXERCISE 4.

Tree Bark

MORE CONTOURS AND CANYONS

1 Focus in closely on roughly 8 × 12cm or so of tree bark. Sketch it very simply, whilst taking note of the bits that come up towards you and those that go down.
2 Compose.
3 Scale-up.
4 Keep your lines jagged and angular.
5 Select a family of colour and add to each contour in progressively light-to-dark tones or vice-versa.

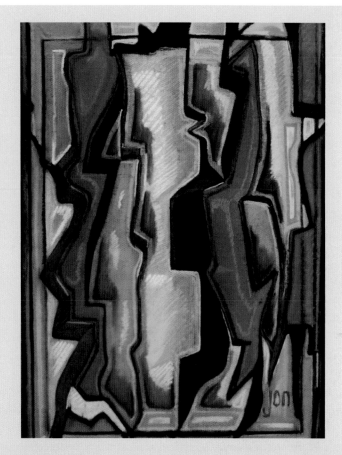

Zig Zag. An image derived from tree bark.

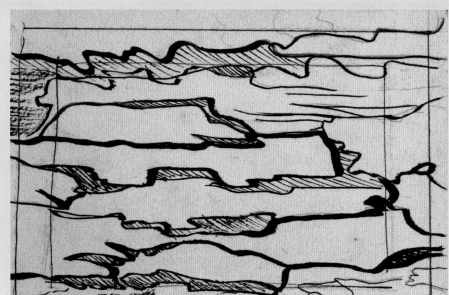

A sketch of tree bark.

Consider what has been achieved within these exercises. We have applied our imagination to resolve curves into straights, to make uninteresting colours into bright vibrant ones, and to look at negative shapes as something to be considered as much as positive ones. We have produced the effect of form (peaks and troughs) by using a spread of colour (yellows to reds) and a spread of tones (lights to darks) within one colour. We are beginning to apply our minds and our imagination to the creation of our own images. We, as artists, are in charge of the image, we are not just copiers.

EXERCISE 5.

Free Marks and Pleasing Hieroglyphics

1 Experiment using carefully mentally prepared scribbles in the sketchbook (think of Eastern hieroglyphics, for example) and endeavour to keep it simple, perhaps using only two or three directions in your free marks.

2 Move up to a larger scale. Choose your substrate, perhaps a coloured one, and choose a suitable colour and as wide a brush or pastel as you have, and develop your sketchbook experimentation.

3 Having achieved a satisfying composition, colour spaces and the background in sympathy. Background is possibly best left as the substrate colour.

Hieroglyphics (1).

Hieroglyphics (2).

Hieroglyphics (3).

EXERCISE 6.

Serendipity

This kind of serendipity can be messy, so take care. There is no need to use the sketchbook in this exercise as Lady Luck will produce the composition.

1 Lie your substrate flat and dab onto it four or five blobs of very watery paint. Quickly tilt the canvas or paper in three or four directions, causing the liquid to create tracks running across the paper. Do this without any attempt to control the result.

2 Lie the work flat again and allow it to dry. The tracks will have enclosed a series of spaces over the surface. If these shapes please you then we can move on. If not, repeat the 'runny' stage until you get a pleasing composition with varying sizes of shapes.

3 Study the composition when dry, turning it around to find the most pleasing orientation. We want to try to pick out a sequence of shapes to colour-in light tones whilst leaving surrounding shapes in darker shades. Think of bright golden yellows surrounded by dark blues, or vibrant pinks with dark greens, for example.

4 Allow the two sets of colours to vary slightly from shape to shape and allow the darker colours to get progressively darker towards the edges of the painting. You are enclosing the light colours in darks. The darker you make the darks, the lighter and brighter the lights appear.

5 Apply the colour flat at first and just concentrate on getting the relationships between tones and shapes to work.

6 When you are happy with the result you can try varying the colour within each shape slightly, from top to bottom and from side to side.

7 Stand the painting up and step back and study it. Once again, turn it upside down and on its sides to see which way up works best.

8 Study the 'tracks' between the shapes. Are you happy with the original colour left by the watery paint you started with, or does the colour need changing in the light of your subsequent work? If you are happy with the way it is, then leave it. Otherwise decide first whether the tracks should be lighter or darker, then decide what colour they should be.

9 Keep it simple and make all the gaps between the shapes the same colour. Should it be a variation of a colour already used? Think of harmony. Or would the painting benefit from a new colour?

10 Once your decision is made, test it out in an area and decide if it is the right one. If not, think again until you are satisfied.

At this stage, having spent one session on the work, it probably is not finished, so be prepared to stand it in a prominent position for a week or two and make mental notes of what adjustments ought to be made. In one quick session, make the changes and then the image is complete and should be signed.

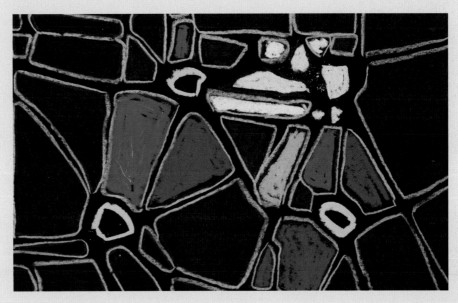

An example of what might result from the serendipity exercise.

EXERCISE 7.

More Serendipity

DRIBBLES AND SPLASHES

For this exercise you need runny paint again, so this is not one for the sitting room in your best clothes.

1 Select your substrate, which can be coloured.
2 Choose a colour of runny paint that works well with the substrate.
3 Lie your chosen substrate on the ground.
4 Dribble the paint onto the substrate, letting it wiggle randomly over the surface to create several enclosed shapes. Don't overdo it.
5 Allow it to dry.

Study what you have. It could be that what you have created works well, in which case leave it at that. Otherwise at least some of the shapes need colour, so select a group of bright colours from a limited palette and select the shapes to colour as flat pigment.

As a variation of this exercise, dribble several colours in a Jackson Pollock way using rhythmic figures of eight.

Another variation might be to use splashes from a brush giving linear marks rather than the wiggled marks of the dribble approach. The two methods produce images with very different dynamics. *See* page 26 for a 'splash' example.

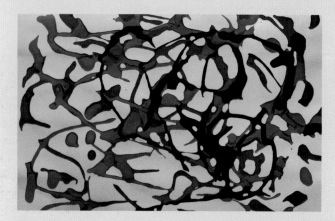

An example of a dribble image.

SUMMARY OF ART MOVEMENTS IN THE LATE NINETEENTH AND EARLY TWENTIETH CENTURIES

Here follows a brief run-down of the movements relevant to the early 1900s and to the development of abstraction in modern art.

1874 – Impressionism

1880s – Art Nouveau

These movements were a stylized, curvilinear reaction to the academic art of the nineteenth century, covering mainly floral and organic subjects. They maintained popularity through to the early 1900s and influenced everything from furniture design to architecture. Exponents included Klimt, Rennie Macintosh, Mucha, Lalique, Gaudi and Tiffany.

1880s – Jugendstil

Literally 'Youth Style', this was the German term for Art Nouveau. Youth Style was promoted by the magazine *Jugend*.

1880s – Divisionism

This was an art movement built on the Impressionists' separation of colours and brush strokes into distinct strokes. Almost all artists of the late nineteenth and early twentieth centuries tried this approach using oblique or horizontal marks or dots.

1880s – Pointillism

Pointillism is a variant of Divisionism concerned with the use of dots in particular. Seurat and Signac are the best known Pointillists.

1880s – Arts and Crafts

The Arts and Crafts Movement was an aesthetic movement emerging mainly as a reaction to the soulless machine-made objects of the Industrial Revolution and from a romantic pride in craftsmanship. It influenced everything involving design, from architecture to fabric design to furniture-making to garden design. It appeared mainly in Britain, the USA and Canada, but also arose in Europe and Australia.

Names connected to the movement include William Morris, Charles Rennie Macintosh, Gertrude Jekyll, Frank Lloyd Wright, Edwin Lutyens, Charles Voisey, Edward Gimson and the Pre-Raphaelites. It had a definite influence on the work of the Bauhaus.

1890s – The Nabis

The Nabis were a rebellious group of art students at the Academie Julien in Paris. They were nick-named after the group of prophets who revamped Israel – because they wore beards, some were Jewish and all were very earnest. They painted realistic and symbolic-to-abstract paintings in mixed media, which are difficult to place under one umbrella. They were, however, tied strongly to the principles of the Impressionists.

The Nabis were led by Paul Serusier, and the group included Maurice Denis, Pierre Bonnard, Eduard Vuillard and Felix Valloton.

1905 – Fauvism

Typified by wild brush strokes and a different use of bright colour, this group formed an important stepping stone between realism and abstraction.

Henry Matisse, Kees van Dongen, George Rouault, Maurice de Vlamink and André Derain were perhaps the best known of this short-lived group (which at one stage included Georges Braque, who took the next step into Cubism).

1905 – Die Brücke

Die Brücke (The Bridge) was a group formed at the Dresden Technical University by four architecture students. They saw themselves as a bridge between what had gone before and the present. They used strong colour and made much use of print-making.

The four friends at university were Ernst Kirchner, Fritz Bleyl, Erich Heckel and Karl Schmidt-Rottluff. Others joining the group included Emil Nolde and Max Pechstein.

1905 – Expressionism

Expressionism involved deliberately painting an image to describe or evoke emotion and was coined, in part, as an alternative to Impressionism. The term can cover any emotion-provoking image. There was no Expressionist movement per se, although it covers die Brüke (above) and der Blaue Reiter (below).

1908 – Cubism

Cubism is a term that covers an important series of steps between realism and abstraction. Seeded in Paris with Braque and Picasso, adherents included Gris, Gleizes, Metzinger, Léger, the Villon-Duchamp brothers and le Fauconier. Linked with the influence of Futurism, Cubism influenced art throughout the world.

1909 – Futurism

Brought about by developments in photography, which some involved in this branch of art denied, the depiction of movement in abstracted images typified the work. The Futurists were anarchists who loved machines, speed, anything modern, violence and war. Dressed in suits, they were wonderful at promoting their cause (the rejection of the past and embracing of the new) – even having manifestos and a road show. Those initially involved in the movement were Marinetti, who was a writer, Boccioni, Carrà, Russolo, Balla and Severini, and many others as the movement developed.

1910 – Rayism

Rayism was influenced by a development in Moscow called ray-gum, which caused photographic images to split into rays and fragments. Mikhail Larionov developed this in his painting and he and Natalya Gontcherova painted rays, which were completely abstract in image although not completely so in concept, for a year or so before giving it up.

1910 – Metaphysical painting

The emergence of metaphysical art involved Giorgio di Chirico and Carlo Carra of Futurist fame, although the two worked together for only a few months. It involves art beyond physical reality and bridges surrealism. Objects are placed in unfamiliar backgrounds and images are placed within others. Others artists involved were Giorgio Morandi and Filippo de Pisis, and the influence of the thought processes involved in this style of art continued to have an influence into the future.

1911 – Der Blaue Reiter

Founded in Munich, this group (The Blue Rider) painted a wide range of subjects and styles, adopting influences from medieval paintings, primitivism, from Fauvist, Cubist and Rayist approaches and moving on towards abstraction. The main artists involved were Vassily Kandinsky, Franz Marc, August Macke, Alexei Jawlenski, Marianne von Werefkin, Gabrielle Münter, Lyonel Feininger, Albert Bloch and Paul Klee. The movement ended in 1914 with the start of the First World War as the three Russians were forced to return home, and Marc and Macke were killed in the war.

In 1923 Kandinski, Feininger, Jawlenski and Klee, all by then teaching at the Bauhaus, regrouped as the Blaue Vier (The Blue Four).

1911 – The Camden Town Group

In 1905 a group of artists, all of whom were very familiar with developments in art in France, assembled in Walter Sickert's studio in Camden Town, London. They were realistic painters, much influenced by the Impressionists and Post-Impressionists, particularly by Paul Cezanne. In 1911 they called themselves the Camden Town Group.

In 1913 they linked with other art groups to become the London Group. The most famous Camden artists were Harold Gilman, Frederick Spencer Gore, Lucien Pissarro and Augustus John.

1912 – The Group of Seven

The members of the Group of Seven all worked for the same design company in Toronto and painted Canadian landscapes presented in a pristine condition and painted in Post-Impressionist styles. With wealthy sponsorship they displayed their work in Ontario. After a break for the First World War they reassembled in Ontario and continued painting. In 1920 they had their own exhibition, which established them as pioneers of a new Canadian School of Art. Membership changed a little and they painted all over Canada, even in the Arctic. By 1930 they were well known in Canada and in 1931 they renamed themselves the Canadian Group of Painters.

The original members were Tom Thomson, James MacDonald, Arthur Lismer, Alfred Casson, Frederick Varley, Frank Johnson and Franklin Carmichael. Lauren Harris and 'AY' Jackson joined them in 1913. Emily Carr was closely associated with the group.

1912 – Vorticism

The Vorticists were a British art group who took their influence mainly from Cubism and more so from Futurism as they too endeavoured to create movement in the image by spinning the eye from the outside into a central focal point. The movement ended with the onset of the First World War in 1914. Wyndham Lewis took most of the credit for the group at their only exhibition in London in 1915, which angered the others, who included Arbuthnot, Atkinson, Bomberg, Coburn, Dissmor, Epstein, Etchells, Gaudier-Brzeska, Hamilton, Nevinson, Roberts, Saunders, Shakespear and Wadsworth.

1913 – Suprematism

Suprematism was a completely abstract form of art based on painting feelings and not things. It was characterized by geometric shapes often seeming to float over the background. The approach was put into being by Kazimir Malevich and its other exponent was El Lissitzky. Malevich's work evolved into becoming more and more simplified until it became a square on a background. There Suprematist painting came to an end, although its philosophy was digested into Constructivism.

1916 – Dada

Dada began in Zurich (but with Romanian and German foundations) as an anti-war reaction. This cultural movement held that war was killing aesthetic, moral and cultural beliefs. They blamed war on nationalism, colonialism and a bourgeois, capitalist society. They advocated a radical destructive and irreverent art that would free them again. The movement was not only an art movement, it also covered literature, poetry, music, theatre and design. Dadaists delivered their anti-war message through manifestos, public demonstrations and publications in literary and art journals.

The movement spread through Europe and North America but it seemed to have most support in the neutral countries where artists not directly involved in the war assembled. There were, however, movements in both Germany and France.

The Dadaist art techniques used were mainly collage, photomontage and the famous Marcel Duchamp 'ready-mades' (items Duchamp thought should be considered as art if taken out of their normal surroundings, like the urinal he called *Fountain* and signed 'R. Mutt'). The artists involved are too numerous to list, but they included most who were around at the time in some way. Dada's influence was strong, but by 1924 it had melded into Surrealism, which changed the emphasis somewhat.

1917 – De Stijl

De Stijl was a publication that expounded the theories of Theo van Doesburg and Piet Mondrian, both of whom painted abstract geometric paintings, with those of van Doesburg using diagonals and those of Mondrian using verticals and horizontals. Strangely, the two friends were to fall out over this difference. Mondrian rejected diagonals and continued painting his psycho-spiritual paintings, which on his arrival in New York in 1940 helped influence the Abstract Expressionists.

1917 – Neo-Plasticism

This term is applied almost solely to Piet Mondrian's grid-like paintings of black lines on an off-white background with blocks of flat colour in red, blue, yellow and grey.

1918 – Novembergruppe

Formed in late 1918 in Berlin and named after the revolution in Germany in the November, this was a socialist group who aimed for a new unity in arts and crafts, architecture and city planning. Although aimed at the working classes it gained more support from the middle classes, who were more able to understand their radical philosophy and could better identify with their abstract art. The movement was made up of architects including Walter Gropius, who would found the Bauhaus school, sculptors, music composers, film-makers and the artists El Lissitzky, Lyonel Feininger, Otto Müller and Laszlo Moholy-Nagy.

1918 – De Ploeg

De Ploeg (the Plough) was formed in Groningen by a group of young artists who wanted a means of promoting and exhibiting their work and new ideas on art, architecture and literature. The initiators were Jan Wiegers, Johan Dijkstra, George Martens and Jan Altinck. De Ploeg still exists, although most members paint in Impressionist style.

1919 – Constructivism

The term Constructivist was applied to the sculptures by Naum Gabo and Antoine Pevsner, which had a mechanical, industrial, angular appearance, obviously owing something to Suprematism. The Constructivist movement in Russia appears to be founded on art being functional and for a purpose rather than 'art for art's sake'. It was, of course, a product of its political times and was all encompassing. The Revolution now dictated art, architecture design for industry, print and publishing, street posters and advertising. The Constructivists' influence spread all over the world and to this day affects design. Unovis and the Bauhaus were both involved in Constructivism.

1919 – Unovis

Unovis is a Russian abbreviation for Champions of New Art, and was formed by students of Kazimir Malevich and other talented staff teaching at the Vitebsk Art School. The group concentrated on current themes and put on a Suprematist ballet and a Futurist opera. They became more ambitious, promoting Suprematist ideals in architecture and design, working with the government and embracing communism. In 1920 they put on a conference in Moscow, which gained them recognition and respect. In 1922 the group split up due to differing ideals.

1919 – Bauhaus

The Bauhaus was a school for fine art and crafts and had its own style and philosophy. Its first Principal was Walter Gropius, an architect who was based in Weimar, but it did not initially teach architecture. Promoting modern design and craftsmanship (aesthetics plus functionality, similar to but more progressive than the Arts and Crafts movement), it had a profound influence on art, architecture, interior design, furniture design, graphic design, industrial design and typography. After six years it moved from Weimar to Dessau, then to Berlin in 1932 where it was closed by the Nazi Party after just a year. Famous names associated with the Bauhaus include painters Johannes Itten, Lyonel Feininger, Theo van Doesburg, Oskar Kokoschka, Vassily Kandinsky, El Lissitsky and Paul Klee, along with sculptors Gerhart Marcks and Oskar Schlemmer.

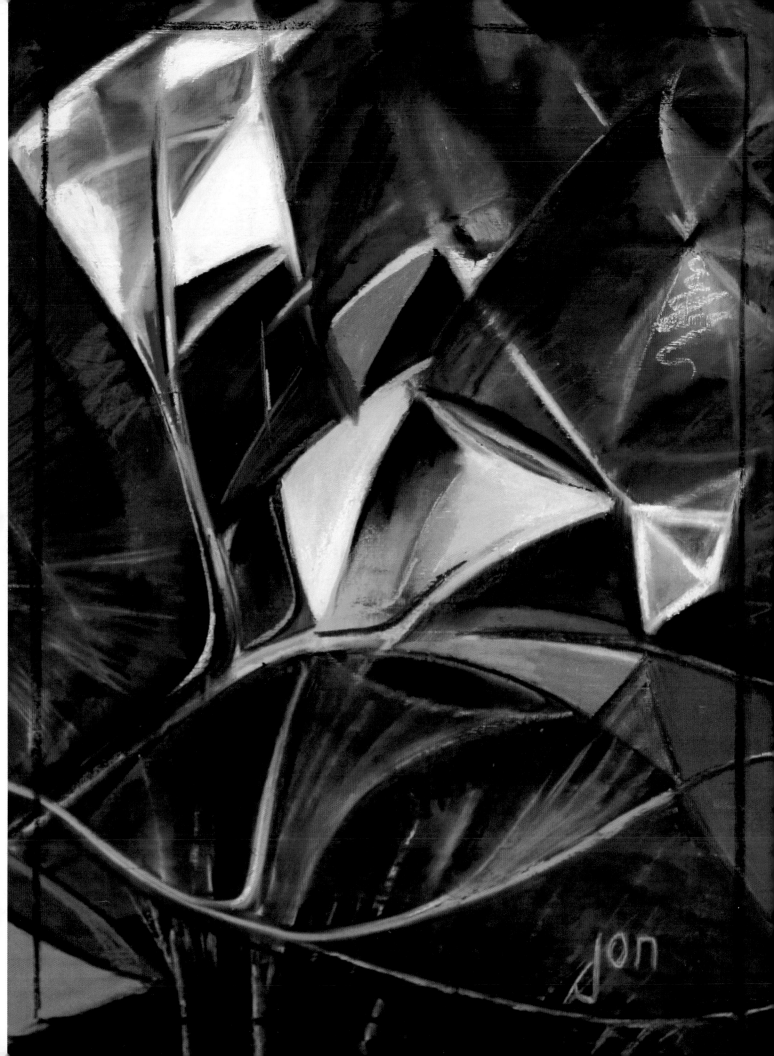

INSIGHTS INTO ART

This is not a practical chapter, as it attempts to address some intriguing aspects of art. If you wish to continue painting, then jump to Chapter 4. However, it may help your practical painting if you have a better understanding of what you are doing and why you are doing it.

On studying art, questions inevitably arise. Here are some attempts – at least partial ones, delivered in a relaxed manner – to answer some of the obvious ones.

WHAT ARE WE DOING WHEN WE PAINT?

When the artist begins to draw or paint, is he doing it for some form of self gratification or self fulfilment, is he wanting to show off his skills and impress others, or is there more to it than that?

When one is just starting with art it is quite natural to want to show off skills and achievements, but the need to paint and draw goes beyond selfish motivation.

Think of a parallel situation of a writer picking up his pen and writing a short story. In part he is writing for his own satisfaction, but really he is writing for someone, a reader, for them to read it and to identify with what he feels. That is where the real satisfaction lies. In other words, the writer is communicating – and that is exactly what the artist is doing. Like the writer the artist is putting something down on paper or canvas in the hope that the reader, or in this case the viewer, can pick up the feelings from the canvas and might even identify directly with him.

OPPOSITE PAGE:
An extract from the top left corner of a foxglove painting.

There may not be many viewers who would read the work in exactly the same way as the artist had in mind at the time of painting. In that way, a painter is somewhat different to a writer. We have all experienced comments from family on seeing our paintings, which show clearly that they can see things in the work that we never even considered when painting it. The viewer interprets what she sees in the light of her own experience. This comes as a shock at first, but does it really matter that people see different things in the same image? Perhaps not – and it can be argued that in many cases there is additional merit in placing ambiguity into the image deliberately. Let us consider this a little more.

OPEN AND CLOSED PAINTINGS: THE IMPORTANCE OF AMBIGUITY

Some paintings are open and invite involvement from the viewer. Others offer quite the reverse. Take, for example, the meticulous and skilful painting of the collie dog in the heather with every hair drawn separately and every heather petal depicted. There is no doubt that a skilled craftsman has produced the piece but there is nothing left for the viewer to add or bring to it, so she rapidly becomes disinterested. The image is 'closed'.

Had there been an added dimension to the image that allowed the viewer to bring along her own interpretation and thereby to get further involved so that her own feelings are stirred, then this would have been a bonus.

Think of the parallel with the writer who, in his thriller, writes, 'George was terrified.' In that statement he has said it all and the reader can add little. Another writer might approach this

Foxglove painting.

by saying, for example, 'George pushed tentatively against the creaking door and peered cautiously into the gloom. Suddenly he felt the hairs on the back of his neck stand on end, the sweat on his temples felt icy-cold and the blood drained from his cheeks …'

In the second case readers are involved in creating their own feelings rather than being told to have them. This should be our aim in producing a visual image: do not spell it out, let the viewer do at least some of the work, and she will enjoy it more. Part of the attraction in an abstract painting may be that each viewer can bring along his or her own interpretation.

Of course, the ambiguity factor adds something to the discussion of the artist simply communicating his feelings and his emotions to the viewer through the image. If viewers can 'read' an image in different ways, then why worry about what was in the artist's mind when he painted it? The problem is that if there is little in the artist's mind when he is creating the image then this shows and the viewer will be disinterested. To have value, the ambiguity has to be deliberately and intriguingly placed. To come back to the parallel with writing, a writer can either be very specific in the meaning of his words, or he can deliberately make them open to different interpretation. Different skills are involved in the two approaches – which is not to say that any one artist or writer cannot have both.

We have established that there are two players in art, the

artist and the viewer, and the latter, when multiplied, becomes an audience. We will talk about the audience later, after we have discussed the artist himself and the viewer with whom he is trying to communicate.

The first image shown in this chapter is based on an extract from the top-left corner of the second image, which is based on a foxglove. Is it more intriguing because it is less figurative and more ambiguous?

THE ARTIST

As artists, we know that our role is not simply that of a doer or maker. We make some marks then stand back and judge what we have done against what went before. This judgement allows us to decide what to do next. We choose colour, the direction of the marks, and so on, and make some more marks. We progress through the picture in a continuous series of painting a section and judging it against the whole, again and again.

So the artist is not just the painter but is also the primary viewer. He visualizes – paints – views – judges – makes changes – paints – views – judges, and so on. As the image progresses he is the one who decides which of the developmental stages is the final one, and when to stop. Sometimes this involves taking

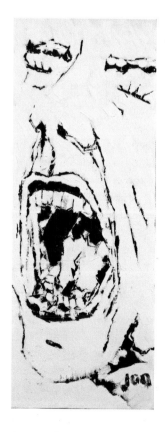

An artist's cry for help – or just 'Top C'?

the picture too far or overworking, but we are, after all, experimenting, and we are bound to test some ideas to destruction in order to learn and to evolve. Most images that 'go too far' can be rescued later.

It is important for all creative people to think of themselves as being on a journey, of continuously gathering experience by analysing the previous work and stepping out in stages from that, or if that route becomes exhausted, by identifying another route to explore. There is no end to the journey.

If success is found with one approach, it is not necessarily a good idea to stick with it. By all means use it and earn money from it – but do not stop exploring. The fact that you have had one success, if you have confidence, means that you can have more. Too many artists gain success but are afraid to move on.

THE VIEWER

There is a tendency to think of the viewer's role as being a passive one, but this is not so. She is, in fact, looking actively for an image that attracts and involves her. It is not quite like the reader browsing the bookshelves, reading the synopses in looking for a book to read because, in the case of a visitor to a gallery, the equivalent to the whole book is visible at once. She sees the subject matter, the style, all the components, all the different levels of involvement, all at once. She decides as to whether it appeals to her and whether she wants to become further involved, within seconds.

The viewer is not just a see-er but is the interpreter, and this is probably the most important role of all, because this determines whether she likes the picture or does not, and whether the picture is purchased or is left hanging in the gallery. She is looking for something extra. Not just the artist's skills. Not just subject. Not just a style. It is something special – something with which she can identify personally.

One has to realize, therefore, that involving the viewer in the image is what the artist should aim for, rather than trying to display his skills. Technical skills are important but they are only one starting point, as the real skills are in the temptation and involvement of the viewer.

Courtship

The need in the artist to attract the viewer through the picture is rather like a courtship process, with the artist displaying as best he can, in the hope that a viewer might be attracted. This is the only reason why the convention of referring to the artist as male and the viewer as female is adopted here. Writing 'he/she' and 'she/he' for the sake of political correctness is boring.

THE AUDIENCE

We tend to think of an audience as being made up of representatives of the whole spectrum of the general public, but specific surveys have been made of those who visit art exhibitions, galleries and museums – and these show that the general public does not seem to appear at all.

The surveys show that those visiting art displays are practising artists, curators of art, owners and buyers from other galleries, art sponsors, art students, art teachers, art critics, interior designers and those more broadly interested in the arts in general. They are therefore far from being a general audience, interested in everything – they are very specific and are interested in art, the arts and things cultural, and in general are knowledgeable and well educated.

Any artist looking to market his work by aiming at the lowest common denominator would probably be making a mistake. Seeking out a unique niche in the market might be more beneficial. The process of trying to address a viewer who is like-minded, suitably informed and sympathetic therefore may not be as difficult as one might have imagined. It would seem that the artist's audience is very receptive and is already tuned in. The like-minded and suitably informed are already there and in place. Perhaps all we need as artists is a little sympathy from the audience.

WHAT ARE WE PAINTING?

We must understand that, when painting, we are not always painting a great work. We can categorize the types of creativity in a picture as:

▓ a note or a quip – a comment on life;
▓ a record – here's how it was;
▓ an observation – here's how I see it, my interpretation;
▓ a statement – here's my opinion; or
▓ a major statement – here's what I really feel about something important to me.

What might start as a note might develop into a major statement, but it is important as an artist to have the ability to categorize work at the visualization stage, to expect an evolution and to be able to judge it at its final stage. It is probably misleading oneself as an artist to begin a piece expecting it to be a major work – not that the quality of the painting is diminished if it is a note, it may technically be a terrific painting, it just may not be communicating anything too important. Think about it. Think also about the later comment under 'Factors beyond the artist's lifetime' on an image having its own intrinsic value beyond the feelings and emotion felt by the artist when painting it.

WHAT IS ART? CAN WE DEFINE IT?

The art world seems to promote the subjective aspects of art to a huge degree, almost as if there was some merit in the very woolliness of it all. In fact, all this does is serve to set the scene in which the confidence tricksters of art thrive. Here are some factors to consider.

Factors apparent in the image

In order to be accepted as art, an image must be original, it must say something, it must be innovative and therefore it must be different to what has gone before. Or it must have some other in-built attraction. It has to involve the viewer in creating some mood or emotion.

As viewers of an image we look for skills – does the artist understand the basics of art? Can he draw? Does he understand the accepted conventions of perspective? Does he understand and use colour theory and put it into practice? Has he studied his subject or is he just bumbling along?

Technical skills need not be apparent in each and every work, as often an artist moves beyond the need to reveal technical skills, working instead with a form of shorthand that involves the viewer more directly. Nevertheless there is an advantage if the artist can display his skills in his portfolio or within his historical work. A display of skills in the artist always builds confidence with the audience.

As a general rule, the more words that are needed to support a visual image, the less valid it is as a work of art. Art is (in most of us) a product of the right cerebral hemisphere of the brain, which is dedicated to creativity but has no verbal language (language is seated in the left hemisphere). In the case of visual art the right brain communicates only through the image and without words, so as soon as the image becomes subsidiary to the words, it is not visual art. (This discussion is developed later in this chapter.) Perhaps images that need a lot of words in their support should best be judged as illustrated text.

In order to be art in its strictest definition, an image must be different, it must intone some emotion (although most would veer away from pieces invoking revulsion and disgust), and it must draw on a background of valid experience and intellectual input. Most of all it must have a hook, something to attract the viewer that other paintings do not have.

WHAT DOES SOCIETY REGARD AS ART?

Factors within the artist's lifetime

The artist's work is only one of the factors controlling what we, as a society, judge as art. Other factors are at least as important as the works themselves. Many of these swing around the personality of the artist. Can he market his work well? Does he have connections and contacts who will help him promote his work? Is he fashionable? Does he attract media attention and thereby become famous or notorious? Does he attract sponsorship? If so, his work might begin to sell for high prices, in which case other factors such as investment apply.

Once major investors collect the works they then become commodities and the powers in society will work toward maintaining their investments by ensuring that prices continue to rise. And, perhaps most importantly of all, once collected and archived the works are then protected for other generations to view and to re-evaluate in the future. If the work is not archived and saved in some way then it will cease to be art.

Factors beyond the artist's lifetime

Once collected and so protected, the works are then in a position to be re-judged by future generations, often using criteria that possibly were not applicable at first. There are examples of artists who within their lifetimes were fashionable, famous and very collectable but within fifty years became dated and were reduced to the stacks of the museum or gallery for many years. However, as long as the works are cared for they can be re-evaluated in the future as fashion changes again and as the ideals and principles used to declare them unfashionable themselves become unfashionable.

Examples abound of artists' work that has been preserved and, even though it was not highly respected within the artist's lifetime, was discovered to be of merit in retrospect. On the other hand, there must be many great artists whose work was not valued within their lifetime, yet which offered a great contribution to art. In this case, if it was not valued and guarded then it is probably lost.

Age often adds a value of its own. The curious thing about a guarded piece of work is that it can become a commodity of value at least partly because of its age and, secondly, it distances itself from the artist as it is interpreted in terms of the criteria of the time in which it is being judged and not by those current when it was painted.

Take, for example, an artist railing about the moral and medical downsides of prostitution in the 1700s. We might now interpret the painting as no more than a valuable record of life in those times – 'What a romantic setting, with the young couples sauntering by the harbour', 'Look at the wonderful sailing ships in the background'. The message of the artist seems to have disappeared with time, but the alternative interpretation is nonetheless appealing in retrospect.

Does this change in interpretation over time (or distance, culture, or society) matter? The artist might expect the audience to recognize what he paints in the picture, but the audience can also enjoy other interpretations. Do images have their own intrinsic value beyond the artist's initial thoughts? It would appear so.

In summary, what society regards as art is complex, involving the artist perhaps more due to his promotional skills and contacts than to his artistic products, which, if they are not collected, valued and protected, cannot be regarded as art (as, in effect, society has disregarded them). If the works are saved and stored, on the other hand, then they have added value due to the passage of time and they are in the happy position of being able to be judged and enjoyed by successive generations.

WHY DO WE LIKE SOME PICTURES AND NOT OTHERS?

There are three layers of influence affecting what we like as individuals. The first is the affect of the society in which we live. In its major galleries and museums a society displays the types of work it supports. Subliminally, society is saying, 'This is what we stand for, this is what we support, as a resident in our society you should support us in this, otherwise we may be offended.' This is a powerful influence and an individual must have a strong case if she is to disagree – so most of us comply and agree that this is what art is about.

The second level of influence lies in the circumstances in which we grew up, including parental and sibling relationships and influences, poverty versus financial comfort, whether we were sporting and keen on the outdoors or reflective and studious, appreciative of the arts or otherwise.

Above these two levels of influence controlling what art we like there appears to be another, broader influence. If the two factors mentioned above were the only influences how would we explain a member of one society liking art from another? Since this does happen we have to conclude that this broader influence is seeded in brain function and could be termed a universal understanding of aesthetics.

WHAT MAKES ABSTRACT ART DIFFERENT?

The attractions in a work of art can be broken down to a list that might include the artist's handling of the following:

- subject;
- composition;
- symmetry;
- line;
- chromatics;
- texture;
- tone;
- brightness;
- form;
- dimension;
- pattern;
- visual rhythm;
- style and use of the medium;
- the reading and understanding of signs and symbols; and
- ability to evoke mood and emotion.

Doubtless there are more.

These criteria are all managed, appreciated and understood by the right cerebral hemisphere, at a level that is later modified by the influences of society and of the life experience mentioned previously.

At the level of brain function we are getting to the core of understanding why we like some works of art and not others. All of these criteria are taken in as part of the judgement process of, 'Is this for me, or do I hate it?'

With a realistic painting, one of the first criteria in the 'Do I like it?' judgement is subject. If you do not like cats then you are unlikely to buy a cat painting, even though all other criteria on the list are met. Therefore whilst 70 per cent of the market (MORI research, 1998) wants realistic paintings and only 20 per cent likes 'modern', the 70 per cent is reduced down to many narrow slices due to choice of subject.

The abstract market, on the other hand, does not suffer from this fragmentation as the work does not have to look like anything. Having removed 'subject' from the list of criteria upon which the picture is to be judged, it is worth noting that all of the others relate directly to the function of the right cerebral cortex (which can approve of the image or otherwise), but without explanation as it has no words.

What we are observing here is that whilst realistic art is much more popular, subject divides it into small fractions. Abstract paintings, however, have a more direct link to the creative brain and might be considered closer to 'pure art'.

Abstract art continues to suffer from an audience that is largely uninformed and also from a lack of understanding of the criteria available through which to analyse it and thereby to judge it. This, of course, must change over time.

Doing versus thinking

The uninformed judge an image simply on a basis of how difficult they perceive it was to create – 'doing' is something most of us understand. They have no way of judging the thought processes involved in producing an abstract image. Judged on a 'doing' basis, many abstracts are not even rated as art because the viewer thinks, 'I could do that – that's not clever.'

Of course, this is a complete misunderstanding of what is involved in abstraction. Abstract images can be a consequence of artistic accidents, happenstance and mindless daubings. We have to accept this. This does not mean such images should be judged as art. Nor does it mean that all abstract art should be judged in the same way. This misunderstanding of abstract art also leaves the field open to exploitation.

Abstract art has to be judged on a thinking basis, not on a doing basis. The trouble is that there seems to be no judgement yardstick available to the uninformed. The only option seems to be 'get involved and try it for yourself'. In order to judge abstract art, you need experience and to have been involved in it yourself. You need to have tried it to know and understand it.

WHY DO WE PAINT? BRAIN FUNCTION: TWO BRAINS TRYING TO WORK TOGETHER

In order to understand art and creativity, it is beneficial to understand a little about brain function.

Humans, unlike any other animal, effectively have two brains that are linked, but take charge of different functions. The right cerebral hemisphere controls emotion and creativity but has little language. The left cerebral hemisphere controls language, number and logic and dominates the right brain, which it uses to express itself, but it prefers to speak for itself first. This explains why an artist, when asked to describe the creative processes in producing a painting finds it difficult and waves his hands in apparent frustration. Gesticulation is also a right-brain function.

An art class, when given a practical exercise such as those we have in this book, reacts initially with silence, rapidly followed by a noisy babble of 'I can't do that', 'What does he mean?' and 'This is impossible.' This represents the left brain complaining because it really cannot understand what is required. After very few minutes there is silence again and the artists start work. In this phase the right brain has taken over its creative responsibilities so the left brain is quiet again and can relax. There follows a period of silence and of painting. Then, all of a sudden it is lunchtime and the artists are saying, 'Is it that time already?' This apparent rapid passage of time is also explained by brain function, as the understanding of time is a left-brain function so

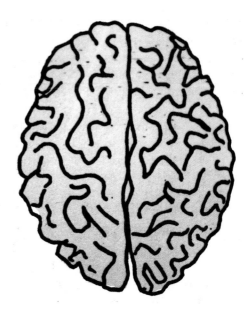

A sketch of a view of the brain from above.

that when the right brain is in charge – as when we are painting – time means nothing.

This dual nature of the brain also explains why the words produced by an artist in describing his work are often 'over the top', forced, elaborate, uncomfortable and less than credible. Read artists' CVs and you will understand. The explanation for this is that the right brain has no verbal language so cannot describe what it is doing, therefore the left brain tries to help. The trouble is that the left brain does not really know what the right brain does, so the words it uses are not quite right.

Similarly a viewer might look at a painting and only be able to say, 'It moves me, but I cannot explain why.' Which means the right brain appreciates the image, but without language it cannot express why. This also illustrates that the right brain communicates directly through an image, with no need for words. This is important.

It is worth listing the functions of the two brains:

Left brain	Right brain
Language	Image
Logic	Intuition
Number	Perception
Linear, sequential thought	Holistic overview
Analysis	Imagination
Time	Space, dimension
Symbolism	Analogy
	Body language
	Gesture

This short list gives the general picture, but we should also remember that the left brain dominates in most people.

The right brain has many functions in common with that of other animals, whilst the left brain deals with the functions that set humans aside. The right brain handles art, its creation and its understanding. Obviously both brains think, spreading the workload as listed above. Both sides also handle movement and visual processing, but in doing so there is a cross-over so that the right brain handles left-side movement and vice versa, and similarly visual messages are processed by opposite-sided brains.

The human brain constitutes an evolutionary record, rather like an early computer being regularly brought up to date by the addition of new parts. The swelling at the top of the spinal cord represents the brain of a fish-cum-reptile; the funny bits of the middle brain (the limbic system) represent the additions to form the brain of a primitive mammal; and the cerebral hemispheres, or cortex, is the add-on to form the human brain. When we talk in shorthand of the left and right brains we are talking of the left and right cerebral cortices, which are made up of layers of nerve cells all inter-linking and transferring information via electronic impulses and by chemical changes where one cell meets another.

Flattened out, the hemispheres are about a metre square, but, in having to be squashed into the skull, they are much convoluted, looking a bit like two halves of a large walnut. The two sides handle different aspects but they do communicate via a dense body of cells called the corpus callosum, which lies between and beneath the two hemispheres. In 5 per cent of humans the two sides swap roles, and in cases of damage other areas take over the damaged area's role to some degree, so there is some flexibility as to where functions are carried out.

The two primary functions of the brain are, first, survival of the individual and, second, perpetuation of the species. Both can be considered to be 'hard-wired', but there are secondary functions with which we are programmed, which appear to be there in order to make life more tolerable – the most relevant of these being creativity.

It is almost as though creativity is there to fill the gaps between fleeing danger and looking for a partner. It would seem that we must create, if only because half our brain is dedicated to it. Unlike a computer, which does not mind if you do not use a piece of its software, the brain does mind – it wants to be used in a creative way. That is why we paint.

A TIMELINE OF EVENTS RUNNING PARALLEL TO THE DEVELOPMENT OF ABSTRACTION

1850 Courbet painted ordinary people.
 Photography began to be in general use.
1870 The emergence and development of Impressionism.
1880 The emergence and development of Art Nouveau, Jugenstil, Post-Impressionism, Divisionism, Pointilism and Arts and Crafts.
1890 The emergence and development of The Nabis.
 Completion of Eiffel Tower.
1895 Roentigen discovered X-rays (received Nobel Prize in 1901).
1900 Monet exhibited his 'Water Lilies'.
 Marey's 'division of motion' photographs on display in Paris World Exposition.
 Puccini's *Tosca* performed in Rome.
 Olympic Games in Paris.
 Quantum Theory explained by Max Planck.
 First Zeppelin flew.
 Commonwealth of Australia formed.

A sketch of a vertical section through the brain.

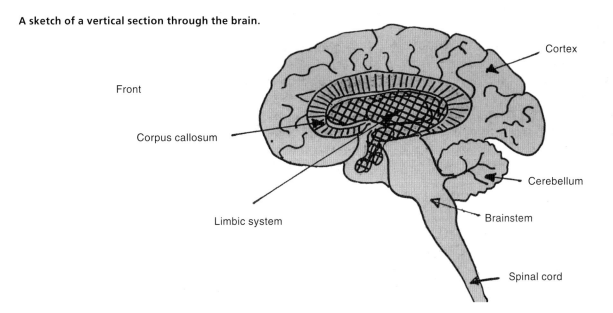

Front

Corpus callosum

Limbic system

Cortex

Cerebellum

Brainstem

Spinal cord

1901 Death of Giuseppe Verdi.
 Marconi sent first wireless telegraphic message.
 First motorbike.
 Death of Queen Victoria.
 Roosevelt became President after McKinley's assassination.

1902 Sir Ronald Ross demonstrated that malaria is
 transmitted by the Anopheles mosquito.
 Racing cars reached 100km/h.
 Cuba became independent from Spain.

1903 Death of Gaugin.
 Nobel Prize for Marie Curie.
 Wright brothers made first flight.
 Buffalo Bill's Wild West Show hit Manchester to great
 acclaim.
 First East–West crossing of the USA by car (it took two
 months).
 First engine-powered taxis in London.

1904 Successful Cezanne show at Salon d'Automne.
 Nobel prize for Pavlov.
 Invention of offset printing.
 Olympic Games in St Louis.
 Remarriage of a divorcee and her adulterous partner
 allowed in France.
 France and England declared entente cordiale.
 Russo-Japanese war over control of Korea and
 Manchuria began (ended 1905).

1905 Salon d'Automne showed the Fauves.
 Die Brücke formed in Dresden.
 The emergence and development of Expressionism.
 Heinz baked beans arrive in the North of England,
 presented as food good for the workers.
 Einstein's *Special Theory of Relativity* published.
 Japan won Russo-Japanese war.
 Sailor on battleship Potemkin shot by officer when he
 complained about food.
 Revolution threatened Russia.
 Norway declared independence from Sweden.

1906 Death of Cezanne.
 Death of Ibsen.
 African art in the ascendancy.
 Salon d'Automne exhibited Russian artists.
 The British Empire covered 12,000,000m^2 (20 per cent
 of land surface).
 USA occupied Cuba.
 San Francisco earthquake killed 700.
 Typhoon killed 50,000 in Hong Kong.
 Finland became the first European country to give votes
 to women.

1907 Klimt painted *Danae*.
 Picasso painted *Demoiselles d'Avignon*.
 Cezanne retrospective at Salon d'Automne.

August Musger invented slow motion films.
Louis Lumière invented colour photography.
France, Russia and Britain signed the Triple Entente to
counter that of Germany, Austro-Hungary and Italy.
Mr Mutt of *Mutt & Jeff* was the first daily comic strip.
Mary Mallon, a cook, infected 51 with typhoid in New
York.
New Zealand became a British Crown Colony.

1908 The emergence and development of Cubism.
 Schönberg composed atonal music.
 First Model T Ford on show.
 General Motors founded.
 Invention of first battle tank.
 Zeppelin No. 4 exploded.
 Earthquake in Italy and Sicily killed 150,000.
 Olympic Games in London.
 Women's Rights demonstration in London.
 The Congo became a Belgian colony.

1909 The emergence and development of Futurism. Marinetti
 published *Manifesto del Futurismo*.
 The Russian Ballet came to Paris.
 Arnold Schönberg composed twelve-tone works.
 Invention of Bakelite plastic.
 Marconi awarded Nobel Prize for physics.
 The arrival of newsreels.
 Blériot flew the English Channel in a monoplane
 crossing 26 miles in 33 minutes.
 Peary became first to reach the North Pole.
 Taft became new US President.

1910 Kandinsky painted his first abstract.
 Matisse painted *Dance and Music*.
 Death of Tolstoy.
 Charcot sailed to Antarctica.
 Dalai Lama fled Tibet following invasion by China.
 First crystal set in USA.
 Duncan Black and Alonso Decker set up a tool company
 in Baltimore.
 Death of Edward VII, George V became king.
 Portuguese monarchy overthrown, Republic of Portugal
 formed.
 Union of South Africa formed.
 Korea annexed by Japan.

1911 Der Blaue Reiter formed in Munich.
 The emergence and development of the Camden Town
 Group.
 Kandinsky book *Concerning the Spiritual in Art*.
 Metaphysical painting established by de Chirico, Carrà
 and Morandi.
 Mona Lisa stolen from the Louvre. Apollinaire and
 Picasso involved.
 Death of Gustav Mahler.

Amundsen became first to reach South Pole.
Marie Curie awarded Nobel Prize for chemistry.
Publication of Rutherford's *Theory of Atomic Structure.*
Revolution in Central China. China became a Republic.
Italy declared war on Turkey in Libya and won.

1912 The emergence and development of the Group of Seven.
The emergence and development of Vorticism.
Apollinaire invented the term Orphism.
First Futurist exhibition held outside Italy, in Paris.
First legal publication of the Bolshevik workers' paper *Pravda.*
Publication of Sigmund Freud's *Introduction to Psycho-Analysis.*
Publication of Karl Jung's *Psychology of the Subconscious.*
Alfred Wegener proposed Continental Drift, disclaimed by scientists.
Olympic Games in Stockholm.
Woodrow Wilson became new US President.
Titanic sank as the band played the hit song 'Autumn'.
The last Emperor of China, Pu-Yi, abdicated.
Mongolia and Tibet separated from China.

1913 Introduction of Duchamp's first 'ready-made'.
The emergence and development of Suprematism.
Modern art came to the USA via the Armory Show amidst consternation.
Mona Lisa is found in Florence.
Stravinsky's *The Rite of Spring* scandalized Paris. Nijinsky danced.
First Charlie Chaplin film released.
First home refrigerator in USA.
Nils Bohr developed atomic theory in Denmark.
Grand Central Station completed in New York.
Ford used a manufacturing assembly line.

1914 Radium used to treat cancer, in London.
Panama Canal opened, connecting Atlantic and Pacific oceans.
Suffragette Mary Richardson slashed Velazquez's *Rokeby Venus* in London.
Gandhi returned to India after twenty years in South Africa.
The First World War began following the assassination of Archduke Ferdinand in Sarajevo.

1915 The emergence and development of metaphysical painting.
Malevich published the *Suprematist Manifesto.*
Death of Rupert Brooke, who was buried on Skyros: '… a foreign field/That is forever England.'
First trans-USA phonecall.
One millionth Ford car produced.
Continuation of the First World War. Italy declared war on Austria-Hungary.

Junkers built first all-metal aircraft.
Italy joined France and Britain.
Passenger ship RMS *Lusitania* sunk by a German U-boat.
Germany used poison gas on Belgians at Ypres (5,000 killed, 10,000 severely injured).

1916 The emergence and development of the Dada movement in Zurich.
Einstein's *Theory of Relativity* published in Germany.
First birth-control clinic established.
Berlin Olympics cancelled.
First British tanks used in the Battle of the Somme (lasting 142 days, 1.22 million dead or injured).

1917 *De Stijl* founded by van Doesburg and Mondrian. The arrival of Neoplasticism.
Death of Rodin.
First recorded jazz concert in USA.
Russian Communist Revolution began.
USA entered the First World War.

1918 Malevich painted *White Square on White.*
The emergence and development of the November-gruppe and De Ploeg.
Death of Gustav Klimt.
Death of Egon Schiele.
Death of Otto Wagner.
Death of Claude Debussy.
Nobel Prize awarded to Planck for Quantum Theory.
Russian Tsar Nicholas II, his family and their dog were executed by secret police.
The Zuider Zee was drained, making the Netherlands almost 10 per cent bigger.
End of the Austro-Hungarian Empire.
Abdication of Kaiser Wilhelm II.
First World War armistice on 11 November.
Weimar Republic founded in Germany.
Inflation devastated the German economy.

1919 The Bauhaus created in Weimar.
The emergence and development of Constructivism, Unovis and Bauhaus styles.
Death of Renoir.
League of Nations formed.
Treaty of Versailles signed.
Formation of the Nazi Party in Germany.
Formation of the Fascist Party in Italy.

1920 Dada exhibition in Cologne.
Death of Modigliani.
Max Wolf demonstrated the structure of the Milky Way.
Olympic Games in Antwerp.
Gandhi began non-violent campaign for India's independence from Britain.
American women obtained the right to vote.

UNDERSTANDING COLOUR PIGMENTS AND THEIR MIXING

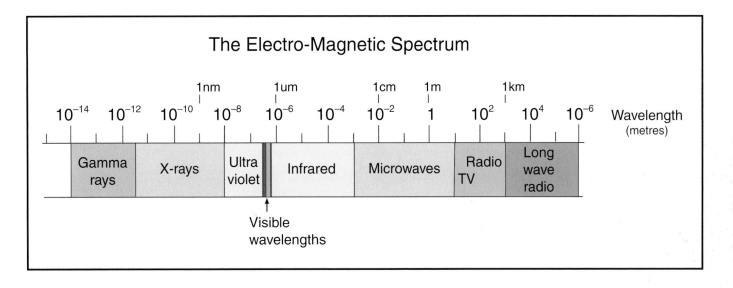

The Electro-Magnetic Spectrum

Ribbons showing wavelengths of energy.

When taking up art, we are usually taught about colour in the early stages. This chapter builds on previous knowledge and gets rid of the woolly loose ends. Understanding colour is not in any way subjective, it is demonstrably concrete.

The aim here is to offer some guidelines and structure to help our use and handling of colour in our practice, to create a language for colour so that we can communicate clearly with other artists and to use a little theoretical explanation to help with analysis and problem-solving.

In the 1670s, Isaac Newton described light as being split into seven colours visible to the human eye by refraction. These he described as red, orange, yellow, green, blue, indigo and violet. We see these naturally in the rainbow as the white light is refracted into its components by fine water droplets in the air. He decided that, because the spectrum started with violet-red and ended in violet, the two ends could be bent round and joined to form a ring or colour wheel. There was no logical or scientific reason for his doing this, other than the similarities of the two end points. But in fact he had created a very useful tool.

We can define colour as a series of wavelengths of energy, part of a long ribbon of wavelengths, a small section of which we can see and the brain can interpret.

OPPOSITE PAGE:
Slava at 70.

53

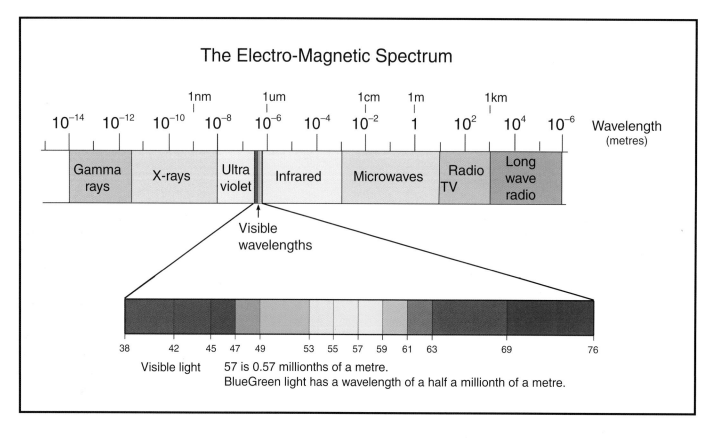

The Electro-Magnetic Spectrum

Visible light 57 is 0.57 millionths of a metre.
BlueGreen light has a wavelength of a half a millionth of a metre.

We can see only a very small section of the full spectrum of light.

THE EVOLUTION OF A MODEL TO DESCRIBE COLOUR

A brief timeline of the evolution of the understanding of colour features at the end of this chapter. The explanation of colour that comes below is based on what has gone before and builds on this.

Our understanding of colour has suffered from flaws in historical thinking, as optical colour mixing (that which now offers us colour television, for example) and pigment mixing were jumbled up. Newton's splitting of light using a glass prism was confused with colour mixing on a painter's palette, and flaws such as this have perpetuated through the years. Here we are going to look at artists' pigment mixing and to avoid confusion will not even touch on optical colour mixing or printers' pigment mixing.

COLOUR THEORY FOR PAINTERS

The traditional theory of colour mixing, as demonstrated by the 1980s colour wheel, describes three primary colours: red, yellow and blue. If we mix red and yellow we get orange; yellow and

The essence of the 1980s colour wheel. The twelve slices of the 'cake' are made up of three primary, three secondary and six tertiary colours.

blue and we get green; blue and red and we get violet. These new colours are termed the secondary colours.

Mixing between primary and secondary colours produces tertiary colours. For example, mixing red and orange produces red-orange. Mixing orange and yellow gives orange-yellow. Mixing yellow and green gives yellow-green, and so on. Notice that we have run out of specific names for these colours.

This is all fine, but it is a theory that does not work in practice.

A simple observation of the colours in a box of paints shows that there are no pure primary colours. There is no pure red, yellow or blue, and there are no pure secondary colours. No pure orange, green or violet. All versions of these colours lie to one side or the other of the 'absolute' colour. Reds, for example, are either violet-ish reds or orange-ish reds. Oranges are either reddish-orange or yellowish-orange, greens are always yellowish-greens or blueish-greens, and so on.

A check with the pigment manufacturers confirms this – at least one of them has tried to manufacture absolutes, but without success. The primaries and secondaries exist only in theory. All the naturally – and chemically – produced pigments are tertiary colours under the terms of this theory. This is a very important point to understand.

A second problem with previous colour studies is that they offer no language for colour, other than description by pigment name. We are still asked to describe colours of paint as, for example, Paynes Grey, or Hooker's Green, often naming a pigment that is probably outdated and has been replaced by some other man-made complex chemical. So there is certainly scope for improvement.

Talking of colour in general terms like orange and green is useful, but it is often frustrating. It leaves one to ask, which orange? Or which green? Clearly the terminology available is not adequate for an analytical painter. This was confirmed by surveying what has been published on colour in the various art books, all of which seem to be very ambiguous, contradictory and unclear on colour – and they sometimes express bewilderment as to why the theory does not work in practice.

In order to avoid all this uncertainty and woolly thinking, reconsideration is necessary: a new model is needed.

This new understanding of colour must be easy to understand and it must be backed by sound explanations that build on the sections of previous theory that work and at the same time it must eliminate the dubious parts. We can do without pretentious and unhelpful associated terminology and terms, and we should try to stick to simplicity, clear thinking and common sense.

The existing colour wheel is only two-dimensional and there are at least three components involved in describing colour, so one dimension is missing. We need a pragmatic, three-dimensional model. To create a more competent theory we have to go back to basics and to look at the components of colour as well as the factors affecting them.

THE THREE COMPONENTS OF COLOUR

1. Colour spread

In its brightest form we call this the spectrum – the colourful colours, which range from dark to light and bright to dull.

The colours we perceive represent a combination of the varying range of wavelengths of light and the way the colour receptors in the brain interpret them. There is a continuous spread of colours in the spectrum – literally countless.

What our eyes and brains recognize is a spread of colours ranging from violet at one end, through red, orange, yellow, green, blue, and back to violet. These are the six names for colour that are in common use, but there is no other significance in the names; there are probably over a hundred colour names in English, if one was to collect them, but the aim here is to keep things as simple as possible.

Now we have the first component of colour – which we all call colour – immediately we have hit on a source of confusion. What we need is another name for the colourful component of colour. The suggestion is that 'colourful colour' be called 'chromatic colour' or 'chromatics'.

2. Colour tone: Light to dark

Each colour can also be described in terms of its lightness to darkness on a progressive scale. The terms dark, medium and light are adequate for most practical purposes, but we can also talk in percentages of lightness, which we will develop later (*see* later section 'The nine-tone colour wheel').

3. Colour intensity: Bright to faded

Colour can further be described in terms of its intensity on a scale of bright to neutral or, to put it another way, bright through faded to colourless. This has nothing to do with the light to dark scale, it is a measure of the purity of colour – the presence or absence of chromatics. At the bright end we have colourful colour but at the faded end we have no chromatics, we only have light and dark versions of no colour. Intensity describes the degree of brightness to neutrality (from brights to greys and browns in simple terms), but it involves varying degrees of chromatic cancellation that will be explained later (*see* later section 'Creating neutrals'). In technical terms the range in intensity can be described as a variation from chromatics (bright, full colours), through reduced chromatics (middling, faded colours), to achromatics (no chromatics, just lights

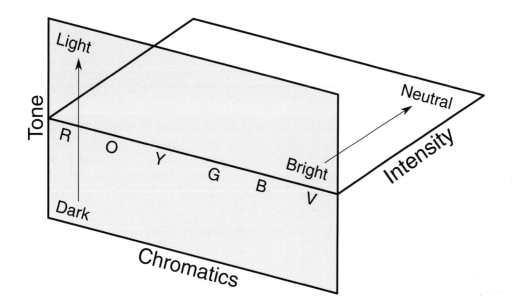

A three-dimensional model showing the components of colour.

to darks). If you find this confusing do not despair, as we will develop this in more detail later.

You can see that there are no new terms here in the colour section, all are in accepted use and in the dictionary.

This information about the three components of colour allows us to build our three-dimensional colour model. All three-dimensional models have three axes, the x-axis (side to side) the y-axis (top to bottom) and the z-axis (front to back). In this case all are at right angles. The x-axis represents chromatics (the spectrum), the y-axis represents tone (lights to darks) and the z-axis represents colour intensity (bright to faded).

EXERCISE 8.

Chopped Kindling

LINE AND OUTLINE, BRIGHT COLOUR, DIRECTIONAL MARKS

1 Imagine chopped kindling lying on the floor and sketch the sticks as varying rough elongated rectangles, with at least one line from each stretching toward the edge of the image.
2 When you are happy with the composition, scale it up.
3 Paint in a dark outline with free marks.
4 Paint the sticks in blues and the backdrop in reds, oranges and yellows using free directional marks, generally radiating out from the centre of the painting.
5 Adjust and, when satisfied, sign it.

Kindling. Sticks in blues with an oranges-to-yellows backdrop offers a fiery feeling.

EXERCISE 9.

Still Life

OUTLINES, BRIGHT COLOURS, STRAIGHT LINES AND EXTRAPOLATIONS

1 Start from your imagination. In your mind's eye you have before you a bowl of fruit. You are looking partly down on it and you have oranges, apples, bananas, grapes, whatever you wish, both within the bowl and spilling out from it.

2 Sketch this in your sketchbook.

3 Draw lines around each chromatic and each tone, enclosing each area or shape with a line. You should not have any unenclosed areas drifting into others.

4 Compose the image using 'L' shapes.

5 Scale-up to your preferred substrate. In doing so, eliminate all curves, resolving them to straight lines with angles between them.

6 Colour all the 'fruit' shapes in the brightest possible colours (for example, bananas in bright gold yellows, with darker shaded sides in bright orange). Really let fly with bright chromatics but leave a gap between the colours for a thick line.

7 Leave the colours applied as flat colour. Examine the whole. What outline would benefit the image? Having used colours from around the colour wheel, then you are probably left with black or white as the best options – but you choose, it is your picture.

8 Now we should examine the straight lines we have produced in the image. How might we extend them into the background in order to integrate the image? Some lines dominate. To extend them into the background would slice the picture into unacceptable sections. Others are more subtle, but to extend them artificially would not be pleasing, so why not off-set them a little? Why not pick up a line, then let it stop and take a rest, then start again at the other side of the picture? Let the eye of the viewer make the links across the gaps.

The Fruit Bowl. **Bright, flat colour with no curves but with extrapolations added.**

EXERCISE 10.

Outline

TONAL CONTRASTS

A. SAND DUNES

1. Seek out pictures of sand dunes. They tend to form wonderful simple sweeps and tonal contrasts. Select a simple image as a starting point. Because it is a simple image you can miss out the sketchbook stage if you wish, as the photographer has probably selected an acceptable composition.

2. Outline the shapes and the lights and darks in dark blue.

3. Colour the sand in golden-yellow and orange, with shadows in dark brown with violet-blue added. Colour the sky in a compatible pale blue.

4. You may wish to grade the colours across the various shapes.

5. Study and adjust where necessary.

Dune shapes in spectrum opposites and strong tonal contrasts with outlines (1).

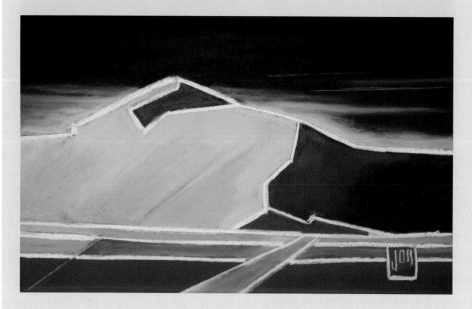

Dune shapes in blues and strong tonal contrasts with outlines (2).

B. SNOW AND ROCKS

1 As a variation to the above select a snowy scene in the mountains, one with rocks revealed amidst the snow.
2 Sketch it in your sketchbook, removing all but the essential shapes.
3 Remove all curves.
4 Scale-up.

5 Paint the snow off-white with pale blue modifications. Paint the rocks in dark-to-medium blues (so we are using a very limited palette).
6 Outline all shapes in dark blue but remember to do so with no curves. Paint the sky in variations of the blue used in the snow.
7 Study and adjust.

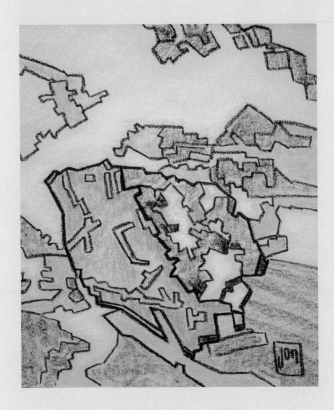

Monochrome blues and off-whites, based on a snow scene but almost abstract (1).

Monochrome blues and off-whites, based on a snow scene but almost abstract (2).

EXERCISE 11.

A Portrait

MORE CHANGES OF CURVES TO STRAIGHTS, SIMPLIFICATION OF TONES

1 Find a newspaper or magazine photograph of a full face with lots of tonal contrast – a black and white photo preferably, and quite big. Study it with the aim of dividing the tones into lightest-light, darkest-dark and (for example) three steps between. Some photos may need more sub-divisions but try to keep it as simple as you can.

2 Take a felt-tipped pen and, starting with the lightest-light and darkest-dark, draw around each tonal step but, at the same time, eliminate the curves – so each curve is resolved into a series of connected straight lines. You are contouring tones in the same way we contour hills and valleys on a map.

3 Scale up this preparatory image to the substrate, maintaining all lines as straights.

4 Select your choice of colour (but not skin colour) and split the colour into a well-balanced group of tonal steps corresponding to the lights to darks you selected on your preparatory image. Your lightest-light might be white and your darkest-dark may be black but your in-betweens will be two, three or four tonal steps of one colour. You are painting in mono-chrome, in other words: different tones of one chromatic that might be dull or might be bright. Paint the contoured shapes according to the chromatic tones selected.

5 We now need to emphasize the straight lines between the tones. The first decision is whether we need a line between, or would the tones look better set crisply edge-to-edge? If it is felt that a line would help, then a line in what chromatic? Try the spectrum opposite so that a painting in blues might have a gold or orange line, for example. Or a predominantly violet painting may take a yellow line. Or try more subtlety – a painting in violet blues works well with light green blues, or a painting in blue violets works well with pale red violets (pinks, in fact).

6 Go to the studying stage and finish later.

President Obama. **Tonal steps, no curves and a limited palette.**

For all you have messed around with lines and colours you will probably find there is still a likeness to the source.

THE ARTIST'S COLOUR WHEEL: A TOOL TO UNDERSTAND THE MODEL

As we have seen, with three components – colour spread or chromatics, colour tone and colour intensity – we need a three-dimensional model to illustrate the interactions. But before we build to discuss use of the third dimension let us start to create the model by eliminating colour intensity from the equation for the moment so that we are left with just two dimensions. This allows us to examine a part of the model showing colour spread (chromatic colour: the spectrum) and colour tone (dark chromatics to light chromatics).

Colours can be fitted into twelve-colour subdivisions, which we call the Principal Colours.

If we form a loop with this strip of colours, joining the two violet ends as Newton did, then we have the basis for the new wheel. On the wheel the theoretical primaries and secondaries are reduced to spokes, whilst the tertiaries are split, as logic decrees, into two sets of third-order colours, so that reds, for example, are either a violet-ish red or an orange-ish red. Yellows are either an orange-ish yellow or a green-ish yellow, and so on.

The colours represented on the wheel are the purest and therefore the brightest available. These are the simplest forms of colour in terms of colour mix that appear to exist either naturally or as manufactured pigment. In practical terms, therefore,

The *x*-axis shows the spectrum of the twelve Principal Colours. This is the first dimension of the three-dimensional model.

| vR | oR | rO | yO | oY | gY | yG | bG | gB | vB | bV | rV |

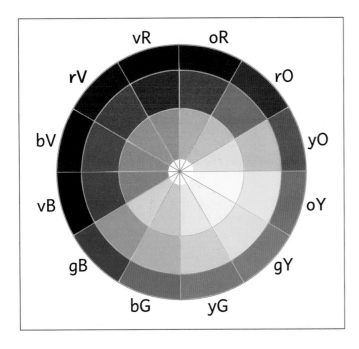

The Simple Principal Colour Wheel shows the twelve Principal Colours split into three tones: light, medium (or full-colour) and dark.

they are the artist's basic colour-building bricks – and each is formed by the old theory, from various combinations of only three colours (two primaries and a secondary).

Unlike before, all the colours to be found in the paint box now fall into one or other of these subdivisions, in a light-to-dark form and in a bright-to-neutral form. On this Simple Principal Colour Wheel, colour tone is represented as light-to-dark by showing a dark version of each colour in the outer ring and a light version of the colour in the inner ring.

A code for colour

Each of the twelve Principal Colours can be named by linking the names of its primary and secondary components. The terminology requires the last of the two colours to be the main one and the other to be the qualifier: so you could have orange-ish red or reddish orange, in other words. It also allows us to annotate these theoretically third-order colours in the same way using upper case for the main colour and lower for the qualifier. Such that oR is orange-ish red and rO is reddish orange.

If we keep it simple and describe the different tones of each colour as dark, medium and light then we have a three letter code, and a simple form of language to describe every colour available. A viridian might be a medium blue-green (or MbG), a cadmium yellow might be a medium orange-yellow (or MoY), and magenta a medium violet-red (or MvR). This annotation is now well tested and allows agreement on how to categorize colours. Yes, we have to accept that there might be a dispute between individuals as to whether they see a colour as (say) a MyG or a LyG, but in practice such minor disagreements do not matter (and, for the most part, artists will place a given colour into the same pigeon-hole).

BUILDING ON THE MODEL

Our colour wheel is, of course, an enormous simplification. The spectrum has been split into twelve slices, whereas in reality we know that that there is a continuous spread of variations. And we have split the tones into only three concentric rings representing a dark version of the colour, a medium version and a pale version when in reality we know that the spread from a dark tone to the lightest tone of that chromatic is infinite.

In addition, we have to remember that the spectrum is linear, not circular. The white light from our sun containing the colours as we understand them covers a range of wavelengths from about 380nm at the rV end to about 760nm at the vR end, having gone through the whole spectrum of colours in between.

The nine-tone colour wheel

A simple addition to aid our understanding involves splitting each of the three tonal rings (L,M and D) into three, which would give us nine concentric tonal rings instead of three.

In order to illustrate this better, we should return to the linear spectrum of Principal Colours and show the subdivisions of the tones in chart form. This is like an un-bent wheel, showing our twelve Principal Colours horizontally, and the nine tones of each of these stacked from dark at the bottom to light at the top.

The twelve colours on the vertical columns have been given their codes and the nine tones on the horizontals have been

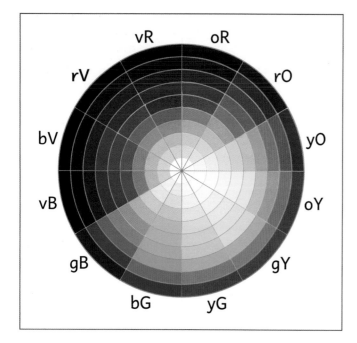

This Nine-Tone Colour Wheel splits the light, medium and dark versions of each chromatic into three further sections, giving us nine degrees of lights to darks. This better represents the brightest colours we find in our paint box.

lightest-light version of each Principal Colour. If we take one small step back from absolute black and absolute white, we can see that each tone will have just a little chromatic in it. These light and dark tones with touches of chromatics are useful to artists.

Our perception and understanding of tones should not be seen as simply the addition of white or black. Instead, let us suggest that the colours lying on the 50 per cent horizontal might be the brightest (most saturated) version of the colour, as one would perceive it in good summer daylight. Colours below the 50 per cent horizontal would be those perceived when this light is progressively reduced, in shadow, or at dawn or dusk, for example. The horizontals above the 50 per cent line represent our perception of the colours with a progressive increase in light intensity such that the colour becomes more and more bleached-out, such as in bright sunlight.

To illustrate this concept, imagine a red car in the sunlight. On the sunlit side one would see it as red, and we would paint it red, but on the shadow side where the light is low, one would not see the colour as red (nor would we paint it red, even though we know it is) but as a dark brown to violet (perhaps as represented on the 15 per cent and 20 per cent horizontals). At the other extreme, where the leading edges of the red car body catch the maximum sunlight, one does not see red, because the

allocated numbers representing percentage of lightness. In theory, the darkest version of each colour would be 0 per cent light and this would, in practical terms, look like a type of black. Conversely, the lightest version of each colour would be 100 per cent light and would, in effect, be a type of white.

You will notice that we are not just discussing one black and one white, which is the way most of us visualize these achromatics. We are looking at a range from the darkest-dark to the

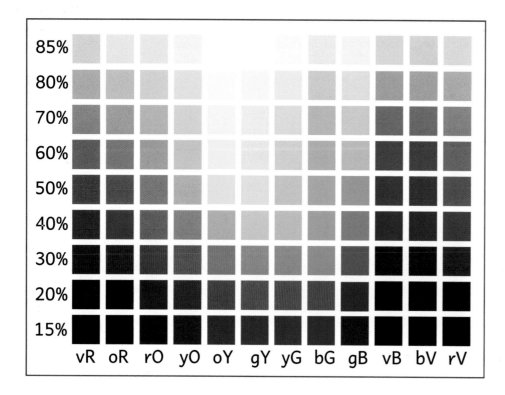

The *x*-axis of the three-dimensional model is represented by the middle horizontal of this chart. This is the full colour, the brightest possible in the spectrum. The vertical range of colours along the *y*-axis represents a range of tonal variations of these bright chromatics.

intensity of the light there means that one might see the colour as light pink to white. The steps of 15 per cent, 20 per cent, 30 per cent and so on have no real significance other than the fact that they represent convenient steps in the progression from darkest-dark to lightest-light.

What we have now created is another representation of an infinite number of colours and tones, which are shown here as nine tones of the twelve Principal Colours. It is clear from this chart that the Principal Colour in its full-colour intensity (on the Prime Chromatic Line) lies on the 50 per cent horizontal where the colours are brightest. We could call this the 'Line of Full Colour'. Below this line the chromatics are progressively obscured by lack of light and above this colour is progressively bleached-out by brightness of light.

This Principal Chart forms two axes of our three-dimensional colour model: the x-axis (side to side) and the y-axis (top to bottom). Before we develop the third dimension, the z-axis (front to back), we as artists have to understand a little more about colour mixing so that we can understand how the colours in the third dimension are created. To do this we have to work with the colour wheel.

THE PRINCIPLES OF COLOUR MIXING

As we have seen, the twelve principal colours represent the purest (that is, unmixed) form of that colour and have optimum tone and maximum brightness/intensity – they are the full colour. The artist's mixing of colours is a subtractive process in that a mixing of any of these principal colours causes colour cancellation and forms neutrals. In simple terms, colour mixing never makes colours brighter, it always makes them duller.

Let us develop this using the colour wheel.

Colour distribution loops

In order better to understand colour, we have to discuss the theoretical distribution of primary and secondary colours. The colour loops illustrations in this section show the distribution of red, orange, yellow, green, blue and violet within the colour wheel. Take the red loop, for example. Red exists in the violets and in the oranges as well as in colours that appear more definitely red, so the red loop starts on the blue spoke, loops through the reds and oranges and stops at the yellow spoke. Similarly, yellow exists in the oranges and in the greens as well as in the yellows, so the loop runs from the red spoke through the oranges, yellows and greens to the blue spoke. Blue exists in the violets, blues and greens so the loop starts at the red spoke

and runs through violets, blues and greens to the yellow spoke. Orange, green and violet, on the other hand, are limited to their own third of the wheel only.

It can be seen that all colour distributions start and stop at the red, yellow and blue spokes. These are the three critical thresholds for colour mixing, as mixing pigments from either side of a threshold causes colour cancellation as spectrum opposites come into conflict.

Problem-solving and a language for colour

The ability to codify a colour and to pigeon-hole it in a precise segment of the colour wheel eliminates ambiguities, allows clear thinking and communication and thereby allows us as artists to analyse our colour problems and thereby deduce solutions. Most of our problems involve colour mixing, colour enhancement and colour neutralization. We will now look at these issues in relation to the terminology relating to the colour wheel.

ADJACENT COLOURS On the wheel there are twelve segments or 'slices of the cake', representing the principal colours in their brightest or purest form with each colour divided into a dark, a medium and a light tone. Any two colour segments sitting side by side are adjacent colours.

PRIMARY FAMILIES Four colours as pairs of adjacent colours sit at either side of a primary spoke: four around the red spoke,

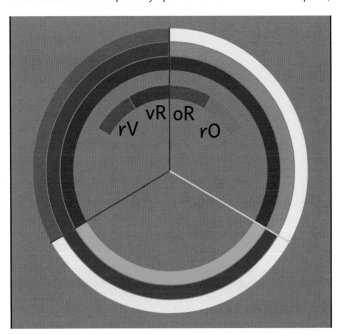

The red primary family.

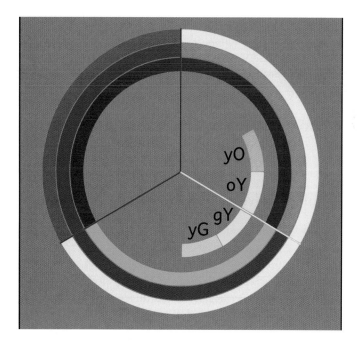

The yellow primary family.

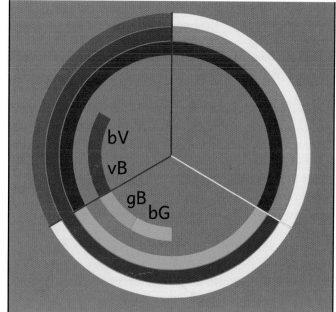

The blue primary family.

four around the yellow and four around the blue. The three groups of four members of each family all have red, yellow, or blue in their names. These are primary families (more on these below).

SECONDARY FAMILIES The secondary families are again three groups of four and these lie between the primary spokes. They include the four colours with orange in their names, the four with green in their names and the four with violet in their names.

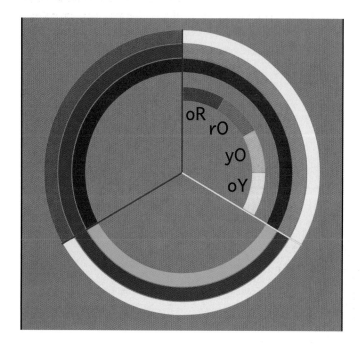

The orange secondary family.

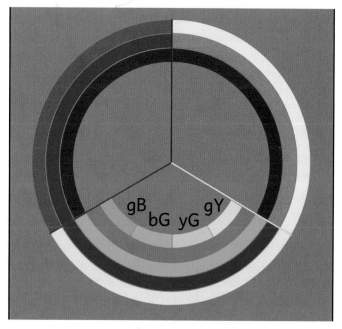

The green secondary family.

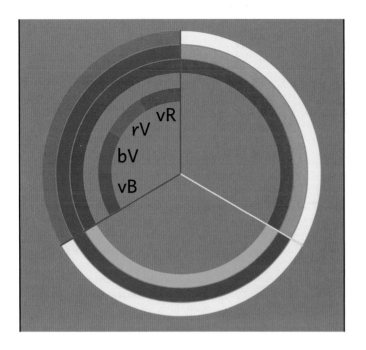

The violet secondary family.

SPECTRUM OPPOSITES Spectrum opposites are those colours lying diagonally opposite each other, through the centre of the wheel. Such colours have been termed '*complementary colours*' as they are recognized as being able to enhance each other – by placing a dash of bG against an oR, for example. This has been said to energize the main oR colour and thereby add to it and complement it.

The Impressionists based much of their approach to painting on this theory. There are several factors involved in how we perceive colours in conjunction with each other, and we will discuss this further in the next section on Visual Colour Mixing. As the main process of colour mixing is a subtractive one (that is, one of colour cancellation or neutralization), then the term complementary is misleading if not a complete misnomer.

Similarly, the spectrum opposite has been termed the *complementary* colour, which is equally confusing as this term suggests colours which, when put together, form a whole, which they do not.

These terms seem to be left-overs from previous generations of muddled thinking and the term 'spectrum opposite' provides a clearer and more accurate description. Spectrum opposites, when mixed, cancel each other out, producing a neutral grey or brown.

VISUAL COLOUR MIXING

If instead of mixing colours on the palette we simply lay two colours side by side, we find that there are several factors involved that affect what the brain perceives. One is the relative size of the two colour marks, a second is the distance between the two colours, and a third is the distance of the marks from the viewer.

If the angle projected back to the eye by the two marks is too narrow then the eye will see them as one and will mix the two colours. Since mixing is subtractive, then the eye will see a neutralized overall colour not an enhanced one. Only when the eye can still see the colours as being separate can we fool ourselves into thinking that separate colour marks create colour enhancement.

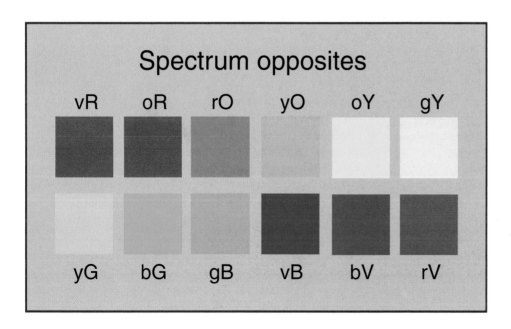

The six pairs of spectrum opposites.

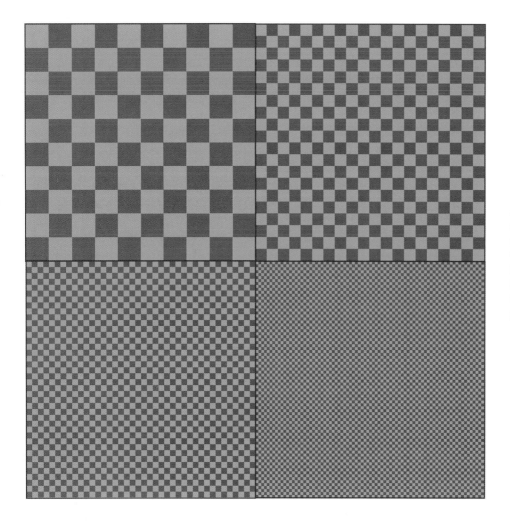

A demonstration of visual colour mixing: as you step back from the chequered board, or as you reduce the size of the squares, the eye becomes unable to distinguish between the two colours and merges them to become more of a neutral grey.

In order to demonstrate this, create a chequered board using two bright spectrum opposite colours. Make the squares about 4cm × 4cm. At close range both colours can be seen as distinct, bright colours. If you step back progressively there will come a stage where the angle of the squares to the eyes becomes so narrow that the two colours mix to create the impression of a dull, neutral colour.

PIGMENT COLOUR MIXING

We have made the point that colour mixing is subtractive, causing colours to dull to a greater or lesser degree. A simple example of neutralizing using spectrum opposites might be when painting a dappled sunlit landscape, where you find that the sunlit patch of bright green you have painted in the centre foreground is just not right. It is too assertive and grabs too much attention. What will you do? Start by deciding what colour it should really be, because, bright, assertive green does not figure on the wheel. If you decide it should really be a light yellow green (LyG), for example, this means that to part-neutralize it we need a touch of its spectrum opposite, which the wheel tells us is a light violet red (LvR). If you are using water colours then make a dilute wash of LvR and paint it carefully over the offending green. If you are painting in an opaque medium then introduce a small amount of LvR and gently mix it into the green and you will find it has stepped back in its assertiveness and is now quite acceptable. If it is not, then mix in a little more. This system of more precise pigeon-holing allows us to avoid some of the pitfalls of colour mixing and greatly helps with problem-solving such as this.

It becomes obvious that proper colour awareness is most important when buying paints. It is obviously best to obtain the brightest possible, as all others can be mixed from these. As long as we have the twelve brightest principal colours plus black and white we will be able to mix all the light and dark variants we might need, and, by mixing progressively more and more of the spectrum opposite with each chromatic we can produce all the neutrals.

It must be said that dark-darks mixed by use of colour cancellation are much richer and more satisfying than using dead,

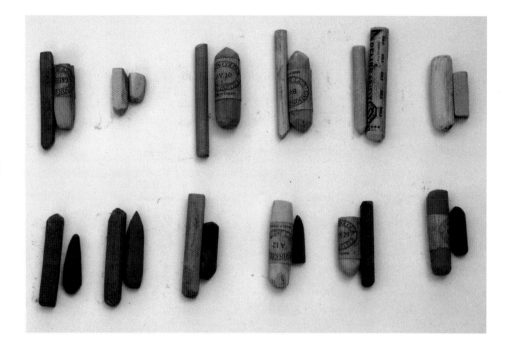

Examples of spectrum opposites using pastels.

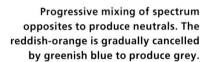

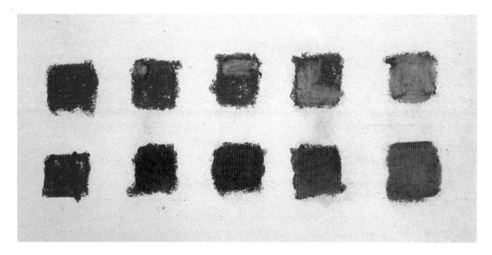

Progressive mixing of spectrum opposites to produce neutrals. The reddish-orange is gradually cancelled by greenish blue to produce grey.

off-the-shelf black. Try French ultramarine with raw umber and err toward the bluish end, for example. Think of ultramarine as a middle-to-dark violet-blue and raw umber as a dark yellow-orange – as spectrum opposites they cancel to produce a dark neutral.

In practice it can be convenient to have as many ready-made colours to hand as possible in order to make life easier. On the other hand, there are artists who gain much satisfaction from the mixing process.

COLOUR MIXING WITHIN FAMILIES OF COLOUR

Mixing within secondary families: colour harmonies

As we have seen, an examination of the colour wheel reveals that between the primary spokes lie four adjacent segments forming distinct families. Between red and yellow are oR, rO, yO, and oY – the codes all have an 'o' (representing orange) in them. Between yellow and blue the family of four all have a 'g' (representing green) in them, and between blue and red the four segments all have a 'v' (representing violet) in the code. Despite being tertiary colours, we term these families

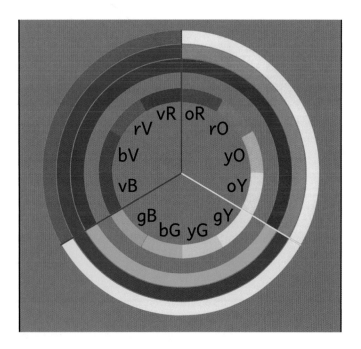

A full set of colour loops. Notice the lack of colour thresholds within the orange, green and violet segments.

'secondary families' as each group of four is unified by having one of the three secondaries in common.

Painting within the range of colours in a secondary family can produce wonderful and harmonious results. Using any two, three or four colours together can produce visual harmony and create mood. They can also be used together with their subsidiary spectrum opposites to great effect. It is hard to go wrong if you paint within these families. This can be explained if we again examine the colour distribution loops.

Between the red and the yellow spokes we have all the colours with an 'o' in their name, and the distribution loops show the presence of red, orange, and yellow. Similarly, between the yellow and blue spokes we have all colours with a 'g' in their name, and these contain yellow, green and blue to varying degrees. In the segment between the blue and the red spokes we have colours with a 'v', containing blue, violet and red. This means that the colours within a secondary family are all compatible and harmonious, with each being derived from mixes of two primaries. Now let us contrast this with what happens within primary families.

Colour mixing within primary families

The primary families do not have complete harmony. These are the three groups of four segments lying across the red, yellow and blue spokes of the wheel, which consist of all colours with an 'r' in their name, all those with a 'y' and all those with a 'b'.

These colours straddle the primary spokes, which are critical thresholds.

As described above, if we examine the graphic showing the distribution of the primary and secondary colour loops around the wheel we see that the red spoke forms the cut-off between the yellow and violet loops and between the blue and orange loops. This threshold is very important in colour mixing. If we were to mix colours from either side of the red spoke, then we can see that the blues in the violets would work against the oranges in the orange-reds and, being spectrum opposites, would cancel each other out. Similarly, the yellows in the oranges would cancel out their spectrum opposites (the violets in the violet-reds) and the result would be a neutralized, muddy red-brown. This happens whenever you mix colours at either side of a primary spoke.

At the yellow spoke, mixing from either side would mix orange with its spectrum opposite blue (there are blues in all greens, remember) and green with red (again, remember there are some reds in all oranges). At the blue spoke, mixing from each side makes some yellow cancel some violet and some red neutralize some green.

So at the red, yellow, and blue spokes there are double spectrum opposite junctions of which to be aware. To mix colours from either side of these primary spokes is to cause a double spectrum opposite cancellation so that a neutral brown or greyish 'mud' colour is formed. When this happens accidentally, without an understanding of the theory, it can be a cause of enormous frustration.

If we do not mix within a primary family, but simply sit the colours side by side, then usually all is well and harmonious. On the other hand, the formation of neutrals is not always a bad thing – quite the reverse. It is therefore worth taking another look at the colour wheel.

Colour mixing within families: Mixing purple

In order to mix colours one must first decide upon the required chromatic in colour terms. For example, if we wish to mix 'purple' (which we will term a medium blue-violet, or MbV), we know we have to mix a member of the red family with one from the blue family – but which ones?

Let us give ourselves the choice of two blues, between French ultramarine and cobalt blue, and a choice of two reds, between alizarin and cadmium red. Once the choices are defined then it becomes apparent which we should use.

It does not take us long to decide that the French ultramarine is a MvB and that the cobalt is a MgB. This means that the blue to use is the MvB, as it sits on the red side of the blue primary spoke. Of the two reds the cadmium is a MoR and the alizarin is

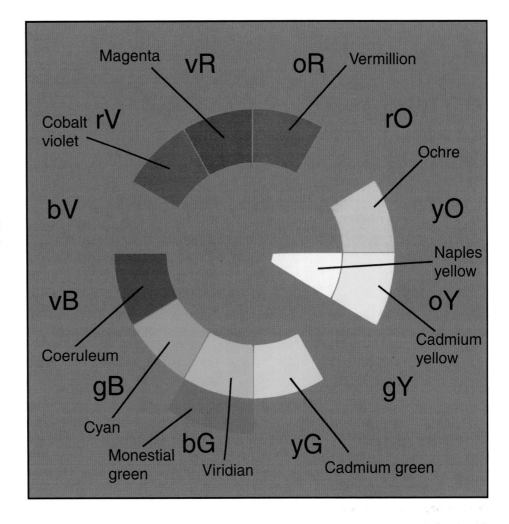

Some common pigments, classified on the colour wheel.

a MvR so the latter, being on the blue side of red, is the one to mix with the French ultramarine to get the medium blue-violet.

Classifying your pigments according to the wheel is a very useful exercise, but if you need help, some of the commonest pigments plotted on the wheel are illustrated here. It is demonstrable that sometimes manufacturers do not make available the full range of colours that we need as artists.

ADDING THE THIRD DIMENSION TO THE COLOUR MODEL

Creating neutrals

As we have seen, the principal colour chart shows the purest, brightest or most intense version of each colour on the horizontal row halfway up the stack (the prime chromatic line, or 'full colours line', if you like) and above this are lighter versions of the colour, with darker versions below.

Let us take two of these principal charts and put them side by side. Now let us pretend that they are two super-palettes, each with pigments in rows of 12 × 9 (so with 108 pigments in each). We will take a dab or a drop of each colour from the palette on the right and carefully mix it with its spectrum opposite of equal tone, in the palette on the left. We can use the colour wheel to help us select the correct opposites.

As we do this we will notice that the effect is to dull down the original bright colour to produce a left palette that looks like Chart B overleaf.

Having done this, if we then take a second drop from the right palette and repeat the process of carefully mixing each colour with its spectrum opposite we will find that the colours are dulled even further as represented in Chart C (*see* page 71), where we have another series of faded or part-neutralized chromatics.

If this process is repeated until the mixes from each palette are about equal, we will have produced a series of dark-to-pale brownish greys – the 'perfect' neutrals. If this colour mixing is done on the computer we get good greys, but in practice the neutrals produced are brownish to varying degrees. This is because paint pigments are not pure.

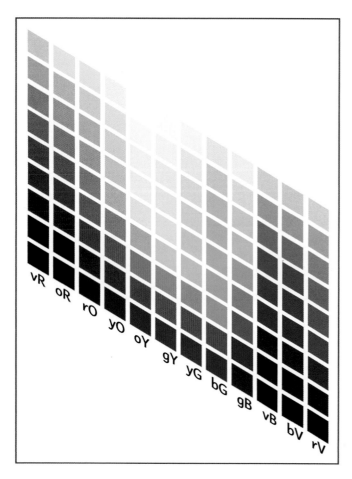

Chart A: The bright chromatics.

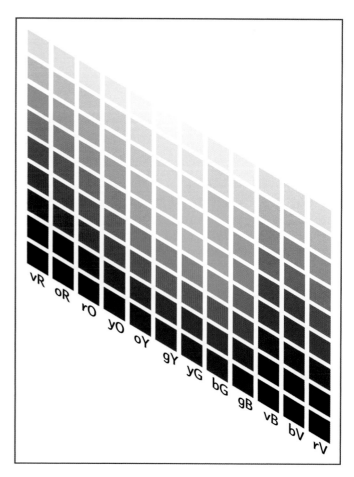

Chart B: The part-neutralized chromatics.

Whilst we are on the subject of impure pigments it is important to point out that, even though a pigment may show, say, oY, it may in fact have some green in it, which, behind the scenes could be causing further colour cancellations. In practice, however, we do not have to worry about the effect of impurities. We artists cannot control impurities, so it is better to be concerned about the things that are under our control.

What we have done in displaying this series of charts showing the progressive neutralization of chromatics is to have added the third dimension to our colour model. In this model the *y*-axis (running vertically) shows colour tone, the *x*-axis (running horizontally) shows colour spread (the spectrum), and the *z*-axis (running front-to-back) shows colour intensity with a reduction from the brightest and purest version of the colours at the front, fading through a sequence of part-neutralized stages to the perfect neutrals at the back.

The 3D model: Charts A, B, C and D showing the progressive neutralization of brights by gradually mixing more spectrum opposites.

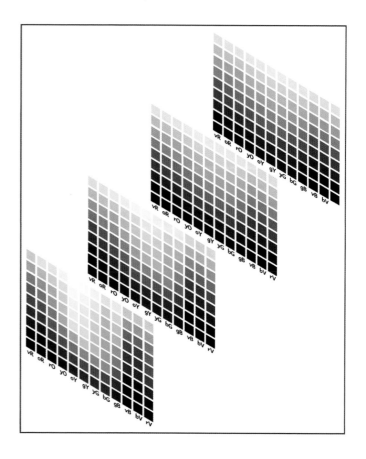

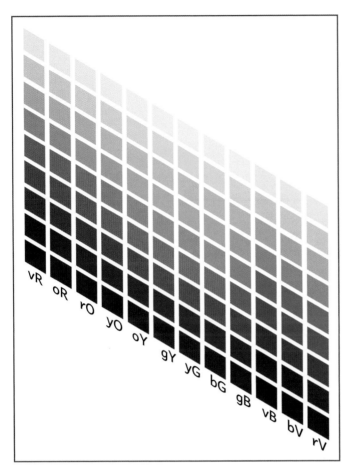

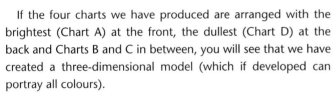

Chart C: Increased colour cancellation.

Chart D: Complete colour cancellation.

If the four charts we have produced are arranged with the brightest (Chart A) at the front, the dullest (Chart D) at the back and Charts B and C in between, you will see that we have created a three-dimensional model (which if developed can portray all colours).

The terms adopted to describe the brightness axis can vary. The simplest and least confusing term is to call it a scale of colour intensity, with variations from 'bright' through 'reduced' to 'colourless' values and these are good day-to-day working terms. Another way is to talk in terms of chromatic colours: chromatics, which are bright, reduced chromatics, which are faded and achromatics ('neutrals'), which are colourless.

Colour brightness as part of our code: The final stage in describing colour

Whilst the colour sensors in the brain are well able to pick out subtle variations within colour spread, intensity and tone, we seem to lack the vocabulary to describe variations. We will therefore keep things simple and again have three categories in order to produce a code.

This code describes bright chromatics as '+', reduced chromatics as '/' and neutral chromatics as '-'. In describing a reduced but darkish blue-green, for example, we might qualify it as /DbG. A bright pale pink might be +LvR, and so on. What we have here is a language and code for colour and the basis for a standardization of colour pigments.

This three-dimensional colour model is illustrated by use of four vertical slices but, in fact, there could be hundreds of slices showing the gradual changes of brights to dulls and darks to lights and the variations in between.

There is an alternative way of displaying the 3D model, and this is to base it on the colour wheel, stacking progressively duller discs to form a 3D cylinder, rather than a 3D box.

The cylindrical 3D model: The brightest brights are on the front disc, with progressive neutralization through the other three discs.

A SUMMARY

▓ We have examined colour and have seen how it is made up of three components: a spread of colours representing different wavelengths of light, tones ranging from light to dark and intensities ranging from bright to colourless.

▓ We have created a language and associated codes to describe the tones and intensities of the twelve principal chromatics.

▓ The colour wheel has been examined as a tool to help us in colour mixing and in understanding and discussing colour.

▓ Harmonious families of colour and critical thresholds have been discussed.

▓ We have talked about creating neutrals by cancelling colour using spectrum opposites and we have a feeling for the importance of neutrals (as we work, for the most part, in neutrals).

▓ We have created two 3D-versions of a colour model to further aid our understanding of colour.

▓ We now have an understanding of how colours relate and interact, which is essential if we are to mix colours for painting and if we are to analyse why certain colour combinations work or otherwise.

The Colour model showing tonal layers.

EXERCISE 12.

Colour Switch in Landscape

1. Select a section of landscape, either in situ or from a photograph, which has a range of colours and is not too complicated.
2. Sketch it, drawing a line around each shape, each chromatic and each tone, so that the shapes are contained and no shape drifts into another.
3. Annotate each shape with its colour code as described earlier in this chapter. Bright green-blue sky might be +LgB, for example. Green-blue foliage might be /MgB; sunlit grass might be +LgB; a pale-pink roof might be –LvR; and so on.

Sometimes it is difficult to decide on the most appropriate colour for a certain shape. Neutrals such as browns and greys often offer problems. The easy way out is to call browns light or dark dull violets, and to call greys light or dark dull blues. You can then use the colour wheel to select the spectrum opposite.

Shadows can also cause problems with colour nomenclature. There is a choice of either calling the shadow a darker tone of what it is overlying (for example, a shadow on grass becomes a dark green), or an even simpler solution is to call all shadows violet – probably blue-violet is best: purple, in other words. This magically makes the landscape sparkle with energy.

Blacks and whites need a little discussion. Remember that there are many blacks and whites. Blacks are the tonal opposites of whites, but they are not the chromatic spectrum opposites. The spectrum opposite to a blue-ish white will be an orange-ish white, and to a violet-ish white will be a yellowish white. The same with the blacks. If at first you cannot decide which black or which white you have before you, then leave them to the end when the rest of the canvas is covered and then decide what version of black or white fits best with surrounding colours.

Enough explanation, now let us get on with it:

4. Still working with the sketch and using a colour wheel, write the colour code for the spectrum opposite under the original code. Put it in brackets if you wish, so as to discriminate between the two. We are not swapping the brightness and tone, just the chromatics, so the sky, coded +LgB becomes (+LrO). The foliage, /MgB, becomes (/MrO), and so on. We are now going to paint our painting in these spectrum opposites.
5. When the codification is complete, scale-up the sketch and paint each shape in the chromatic as dictated by the spectrum opposite code. Just apply flat colour without texture or form. Leave enough space between the shapes to allow a line to be added later.
6. Having coloured in all the shapes, be prepared to adjust associated colours for the sake of the picture, as sometimes our selected spectrum opposites do not sit comfortably side by side.
7. Stand back and study your work. You have created an image of a Martian world with familiar shapes represented in alien chromatics. Tones should look right and brightness levels should look right, but the chromatics are wildly different from real life. Look at what you have created not in realistic terms, but simply as an image. If the colour switches have been done well, then the image should all be in balance and should be pleasing as well as exciting.

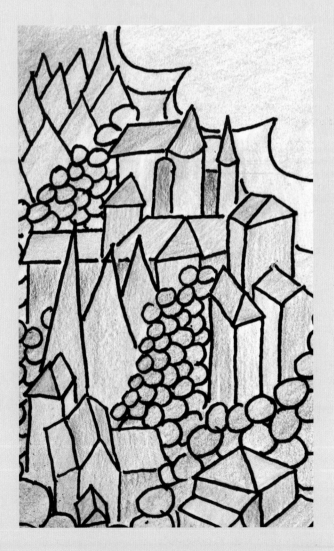

A sketch for colour switching.

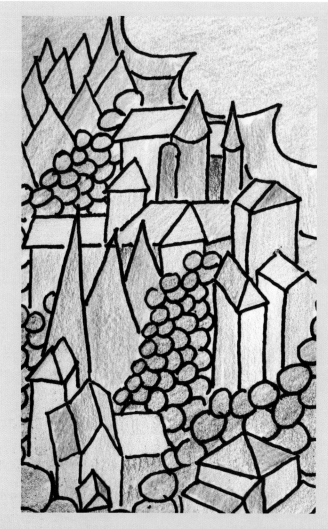

The result of a colour-switch exercise.

8 We are not finished yet as we have to select an outline to put around the shapes. Think of a stained-glass window – bright colours outlined by dark lead. Decide whether a dark outline would be most suitable for the overall picture. Think about the predominant colours the switches have produced. Greens have changed to reds, blues to oranges, and so on. If these colours prevail then perhaps a dark blue would be the best choice for an outline – or perhaps a dark red. If you have ended up with a multi-coloured picture, your safest choice might be a black or white. Do not be drawn into applying multi-coloured outlines, as the single colour acts as a skeleton holding the image together. Be aware that, by using flat colours and a single-colour outline, the image has been brought to one flat plane, that of your canvas. Perspective has been minimized – but there is nothing wrong with that in the world of abstraction.

9 At this point the image is almost complete. Let it simmer for a couple of weeks, make final adjustments and that's it: finished.

There is a lot to be learned from this exercise, which can be mind-boggling at first but is relatively simple. Having started from a realistic image, by applying mental steps we have brought the realistic into the world of abstraction. Creating abstract images from the serendipity can be so exciting, but doing it through a series of thought processes can be much more satisfying.

This exercise reinforces one of the fundamental steps toward abstraction, which is that the artist and his mind are in charge of the end product. The 'rules' have changed. It is not how things are that is important, rather it is how we choose to interpret something in our minds that produces the abstract image.

There are contrasts other than light to dark to be explored. Let us now consider experimenting with brights to dulls.

EXERCISE 13.

Brights to Dulls

Look at the examples here from the 'abstracted' category. Using a limited palette of brights represented by paint on paint brushes and in cans viewed from above, the shapes became less representational and more 'gloopy'. Notice the use of a carefully placed splodge of spectrum opposite.

These examples all demonstrate the contrast between bright chromatics and achromatics, a combination of which can produce powerful images.

1 Select a subject and sketch and compose in the usual way.

2 Scale-up and choose a family of strong brights for the colourful parts and a family of greys for the achromatics.

3 Decide whether you should eliminate curves, as with the melons picture, or whether you wish to use outline.

Paint Brushes (1).

Paint Brushes (2).

Sauces. Another brights-to-colourless experiment based on bright 'sauces' and neutral stainless-steel 'saucepans' viewed from an unusual angle but otherwise representational. This might fall into the 'abstract-like' category.

Melons. Another brights-to-colourless contrast with bright 'fruit' with curves removed, working with a dull background of greys. Textured marks are added.

EXERCISE 14.

Exaggeration

1 Sketch a coastal scene with a lighthouse, perhaps with some other buildings taking up much of the picture, with a wild stylized sea in the foreground and a crazy waving sky as a backdrop to match the style of the wild sea.

2 Compose and scale-up.

3 Add colour using dark blue-violets in the sky, blue-greens for the buildings and pale violet-reds for the sea.

Aldeburgh Lighthouse. The town of Aldeburgh in Suffolk, England is being eroded by the sea, which in this image is over to the right-hand side. In endeavouring to portray the bushes in front of the lighthouse, the idea came to depict symbolically the threat of the sea to this picturesque town. It is painted in gBs against a general background of bVs, vBs, rVs and vRs.

EXERCISE 15.

Switches Over Lines and Borders

Six suggested configurations for switches over boundaries.

This is a great exercise as it allows us to mix up all the contrasting tools in one picture. The exercise adopts one subject but treats it in different ways in different areas defined by border lines or by zones within the image.

1 Examine the sketched suggested borders or zones shown here. Observe the change of approach over borders and zones.

2 Select a subject and a configuration of boundaries to suit you. Let your imagination roam. You have many choices with what you could contrast in your work, here is a selection:

- Realistic chromatics vs spectrum opposites
- Chromatics vs monochromes
- Textures vs flats
- Straights vs curves
- Lines vs edges
- Dislocations

3 Make sure the subject covers the whole picture, so that the changes over borders are apparent. It is no good having your vase of flowers (or whatever) in the middle and your border around it, as you will have nothing on which to do the switches.

Daffodils. **The example shows a switch from black and white in the centre, to colourful in the broad border.**

THE JOYS OF MONOCHROME

Now that we understand colour, we know that chromatic colour can be used in several ways. Bright chromatics and subdued chromatics can be used to great effect for placing different moods in an image. At one extreme, however, chromatics can be missed out altogether, thereby creating images with their own special qualities. Either one can paint in achromatics, in a series of greys, or one can paint in differing tones of a single chromatic (blues, for example) or in a pair of adjacent chromatics (yellows through to golds, oranges and browns work well).

We have studied colour and we have discussed the benefits of painting with reduced palettes, but we need to give a little more emphasis to painting in monochrome. It is almost as if you have to understand colour to know that very often it is better to eliminate the chromatics and just paint in tones of a single chromatic.

Do not get confused with the term monochrome. You are painting in one chromatic, not just blacks, greys and whites. You are painting in monochrome, but you are using tones of that chromatic. Different tones of blues work well, but try different tones of greens, violets, or any other chromatic. If you wish to achieve an 'olden days' atmosphere, try sepia browns like those in old photographs.

Possibly monochrome works best at the realistic end of the scale but it can also work well with abstracts. It is certainly an approach with which we should be familiar.

Here are some subjects illustrating the use of monochrome. Try this approach yourself in practice.

Tendulkar.

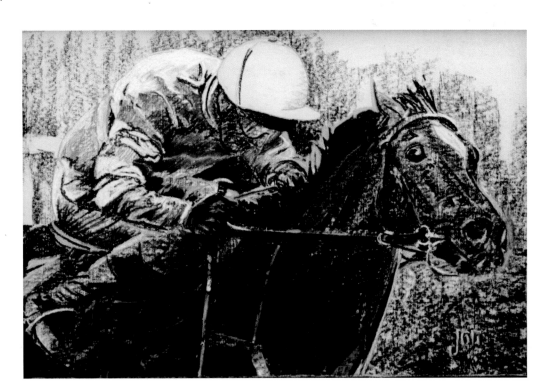

White Cap.

A Hard Day at the Office.

A TIMELINE OF THE UNDERSTANDING OF COLOUR

1648	Bohemian physicist Marcus Marci split white light into its component colours.
1650	F.M. Grimaldi in Bologna described diffraction (without using the term).
1670s	Newton in England first described light as being split into seven colours visible to the human eye by refraction. These he described as red, orange, yellow, green, blue, indigo and violet. We see these naturally in the rainbow as the white light is refracted into its components by fine water droplets in the air.

Newton in England first described light as being split into seven colours visible to the human eye by refraction. These he described as red, orange, yellow, green, blue, indigo and violet. We see these naturally in the rainbow as the white light is refracted into its components by fine water droplets in the air.

He split his colours into seven colours (to match the 'notes' of music) as at the time he was making comparisons between colour and music (which he quickly decided were not valid). Amazingly, this concept of visual art being represented in the same way as music rolled on into the early twentieth century.

Newton also decided that, because the spectrum started with violet-red and ended in violet, the two ends could be bent round to join to form a ring or colour wheel.

1686	Edmund Waller produced a colour square based on Yellow, Red, Blue and Green.

MVP 1.

1740 Luis Bertrand Castel invented a twelve-colour wheel that included light versions of some colours.

1758 Tobias Mayer in Gottingen invented a colour triangle.

Late 1760s Moses Harris examined Newton's work and produced an eighteen-segment artists' colour wheel, which included the three primaries and the three secondaries and two variants of each. He points out that all colour mixing is subtractive (which is important as he was concentrating on the mixing of pigments).

1772 Johann Ignaz Schiffermüller produced a twelve-colour wheel based on RBGY with three greens, two oranges and four violets.

1772 Johann Heinrich Lambert, an astronomer from Mülhausen, Alsace, produced the first 3D-model for colour, a pyramid, which became a cone based on a twelve-segment RYB subdivided wheel.

1801 Thomas Young, a doctor and physicist, proposed tri-chromatic theory based on his belief that the eye perceives RGB. Helmholtz built on this 50 years later.

1809 Philipp Otto Runge, a painter in Hamburg, created a colour sphere. It had chromatics around the middle, with white at one pole and black at the other.

1826 Charles Hayter produced a colour compendium based on RYB, moving to secondary orange, purple and green in an inner ring and then through neutrals to black in the middle.

1846 George Fields talked of six primary colours and introduced the terms 'hot' (Red) and 'cold' (Blue) as well as 'advancing' and 'retiring' colours (interpretational terms which do not add to our understanding).

1855 James Clerck Maxwell, a Scottish physicist, worked on colour measurement using RGB and VRB triangles.

1860 Hermann von Helmholtz, a scientist and philosopher, produced a model based on RGV and white.

1905–15 Albert Henry Munsell in the USA described ten colours – red, yellow-red, yellow, green-yellow, green, blue-green, blue, purple-blue, purple and red-purple – and he formed a ten-segment colour wheel. He also described the differing light-to-dark versions of the colours gained by adding black or white. He discussed varying chromatics, which he described as variation from a pure colour (which he terms 'hue') to a grey version of that colour, and he discussed tones (light to dark) as 'values'. This gave the wheel a third dimension, giving an ordered system for describing colour that is still used by many today, especially in the USA.

Early 1900s Johannes Itten, who later taught at the Bauhaus, created a colour wheel and 3D-colour loops that took colours progressively to black and to white.

1916/17 Wilhelm Ostwald, a chemist, created a double-cone model based on a 24-colour wheel.

1922 Arthur Pope, a painter in the USA, created a double-cone 3D model with a RVBYO colour wheel tapering to white in the top cone and to black in the basal one.

1924 Max Becke, an Austrian chemist in the textile industry, produced a cube colour model.

1948 Aemilius Müller published a 3D cube model based on RYB, OVG and black and white.

1952 Alfred Hickethier, a German printer, produced a colour cube that he hoped would be of practical use in industry. Unfortunately it involved specific dyes so did not prove practical in other industries.

Late 1980s The artists' colour wheel that is available in most art shops was produced and has proved to be of value to artists since. This displays three primary colours (red, yellow and blue) plus three secondary colours (orange, green and violet, formed by mixing the primaries) then six tertiary colours (formed by mixing the primaries with their adjacent secondaries), so that the sequence runs: red, red-orange, orange, orange-yellow, yellow, yellow-green, green, green-blue, blue, blue-violet, violet and violet-red. This colour wheel introduces pretentious terms that serve no purpose.

1987 Michael Wilcox, concerned with practical colour mixing for artists, published a nine-colour 'Colour Bias Wheel' based on the primaries RYB, which he said do not exist, and on secondaries VGO, which, when mixed, form six tertiary colours.

This is by no means a comprehensive history of the understanding of colour, but, for painters, it serves to offer a background to the mental struggles involved in understanding colour.

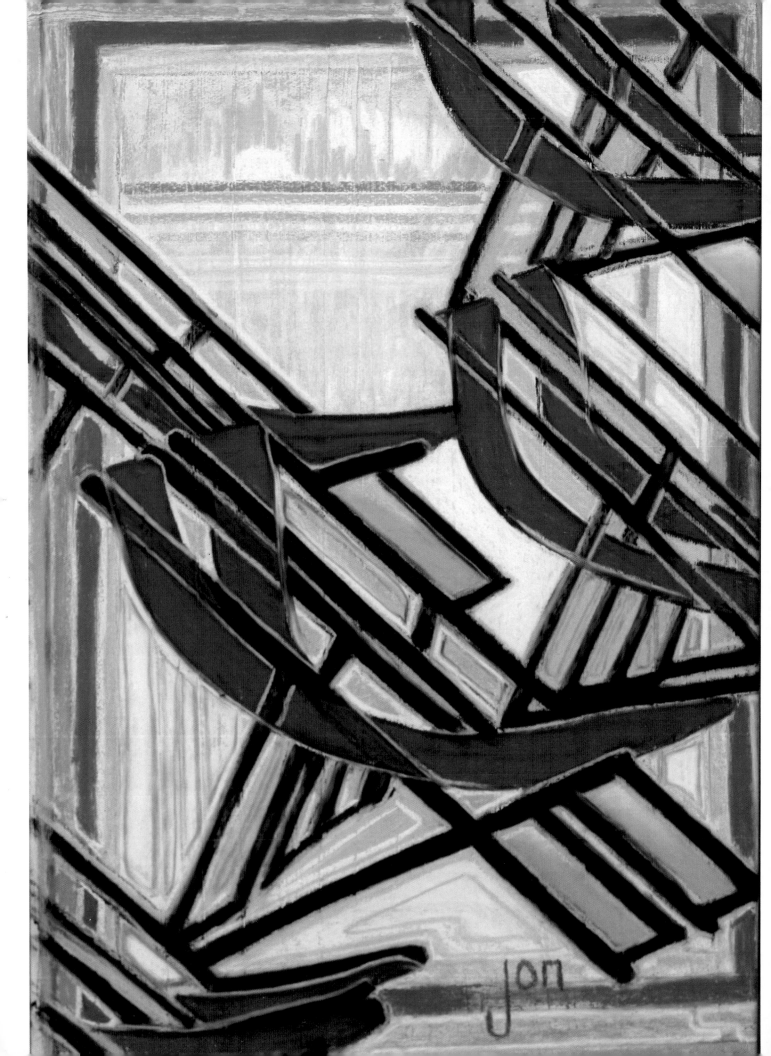

MORE PRACTICAL EXERCISES

It is now time to look at the application of the abstract artist's tools to various subjects such as still life, figures, portraits and landscapes, and to examine some of the work of a few artists at critical stages in their development.

USING THE TOOLS OF ABSTRACTION

As all artists are different, we will all develop our favourite tools with experience and over time. In this section we will examine the use of some of the simplest and most effective tools.

As a broad generalization we can say that simplification is the basic tool of abstraction. In this chapter we will practise the use of strong outlines combined with the straightening out of all curves into angled straights (like a six-sided coin, for example). Outlines can offer an overall skeleton with which to bind the image together. Straights start by taking the image on its first step toward abstraction, but they also offer lines for us to extend (sympathetically) into the background.

We will also try chromatic switches – the changing of a colour as we see it to a colour of our choosing. We will also address the reduction of colour spread, by working within a limited palette and by working in monochrome. The use of limited colour can produce harmony and create mood in an image.

Here follows a series of practical exercises that make use of some of these specific tools.

OPPOSITE PAGE:
Deck chairs.

EXERCISE 16.

Close Focus and Blur

1 Focus close-up on a plant or flower, preferably something from the thistle family or something with multiple florets forming spirals or complex seed heads.
2 In your sketchbook draw the plant so that it fills the page, spilling out of it. Sketch it simply and roughly – this is not botanical drawing.
3 Simplify the seed head or spiky head into a series of crossing diagonals.
4 Simplify petals and leaves; this can be done using straight lines with angles between them.
5 Think of the colours you would like to be in the final painting. They can be realistic if you wish.
6 Scale-up.
7 Add the colour.
8 Extrapolate and offset lines (do not artificially extend lines) from the head of the plant into the background.
9 Carefully blur anything not in the plane of the main subject.
10 Give the result some thought and adjust if necessary.

Echinops sketch.

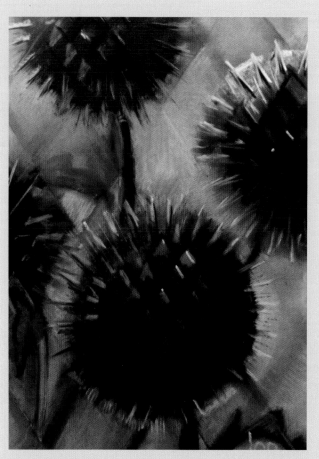

Echinops completed painting. The Echinops heads are resolved into diagonals, which are repeated in the spectrum opposite backdrop.

EXERCISE 17.

Simplification

1 Select a subject with structures. It could be a building, a crane and lifting gear, scaffolding, whatever. Just ensure it is a subject that offers verticals, horizontals and diagonals.
2 Simplify the directions of the structures into verticals, horizontals and diagonals in your sketchbook. Resolve other shapes into geometrics.
3 Scale-up.
4 Decide on a colour family plus limited spectrum opposites and add the colour.
5 Add a backdrop to complement the colours used.

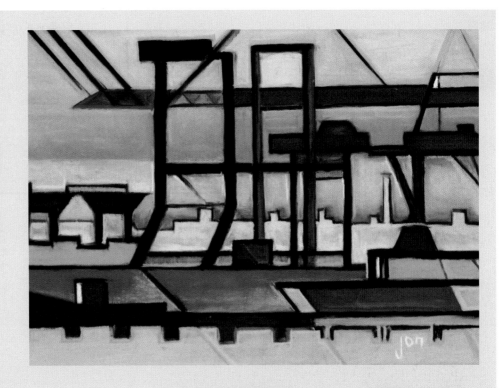

Port Palimpsest began as a distant view of Harwich port in the east of England. It involves the simplification of lifting gear and of ships and the creation of linear rhythms involving verticals, horizontals and diagonals. Notice the limited palette.

Architectonics began as Threlkeld Quarry, east of Keswick in the English Lake District. It became simplified into the geological components of bedding, cleavage and joints. Then, by playing with linear perspective, extra dimensions were created.

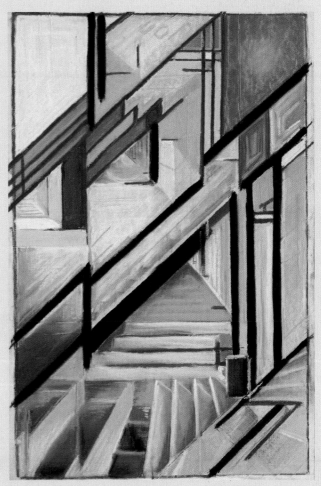

EXERCISE 18.

Elimination of Curves

1 Select a subject that is typically curvaceous, such as fruit, flowers or people.

2 Create a composition in your sketchbook, converting all curves into a series of angled straight lines.

3 Scale-up.

4 Add colour, using bright and exaggerated realistic colour for the subjects and dull greys for the backdrop. This should create an enjoyable bright-to-colourless contrast.

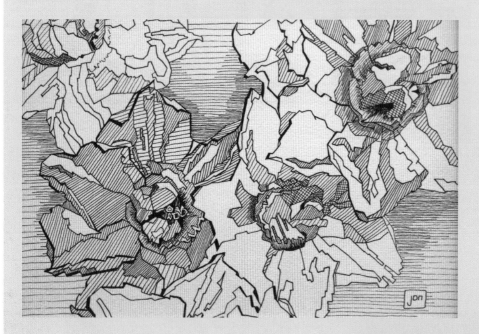

Double Daffodils. **A close-up of a line drawing showing the daffodils to be abstract angular shapes.**

Berries. **This makes use of spectrum opposites and straights.**

MORE FOCUS AND BLUR

A blurring effect can be used to produce hierarchy, movement and atmosphere.

EXERCISE 19.

The Elimination of Straights

1 Using a narrow vertical format rather like looking through the slot of a vertical letterbox, sketch a slice of a townscape.

2 Convert all straights to curves. All buildings therefore become bendy.

3 Scale-up.

4 Exaggerate the curves by outlining them in dark blues and paint the buildings in yellows, golds and oranges, emphasizing darks and lights within the yellows.

Muker. **A bendy rural landscape from the Yorkshire Dales in the north of England, formatted as a vertical letterbox.**

In the monochrome *Blue Echinops* the spiky balls are in focus, telling us that these are important, and the background of leaves is out of focus and therefore not of prime importance.

In *8765* blurring in the form of directional drag is used to imply movement and speed.

Try all of these approaches. By now you should be getting the hang of these practical exercises, so try organizing your own.

Rain On My Specs is a tongue-in-cheek townscape on a rainy night with raindrops causing distortions.

In *9.11* the blurring offers dust and smoke, adding to the atmosphere of this horrific occasion.

TEXTURE

The direction and size of marks can contribute greatly to the atmosphere, style and dynamics of an image. Painting in dots creates a very still image, whilst regular, unidirectional hatches add a tapestry-like shimmering effect. Coarse, irregular marks increase dynamism. Blocky, broad-brush marks offer a freedom from detail and an individual style.

EXERCISE 20.

Creating Texture with Hatches

Cezanne, the Divisionists and later Roger de Grey used hatches to great effect. Cezanne used unidirectional oblique top-right to bottom-left marks. The Divisionists used all manner of marks, but one of the most successful approaches is that of early Kandinsky, when he used short horizontal marks so that the image seemed to be built of bricks. Roger de Grey used fine oblique marks, anchored occasionally on horizontal marks.

The only approach which does not work too well is to hatch in one direction, then the other, as it has the potential to give the viewer a sea-sick feeling.

A. HATCHED LANDSCAPES

1 Sketch your landscape.
2 Scale-up.
3 Either under-paint in a flat colour and over-paint in hatches or go straight in with unidirectional marks. Do not use geometric, 45-degree marks, but 'hand-made' marks with some variation. Marks are to be made in a deliberate manner, they should not resemble scribbles. This is a fairly laborious approach but there are no short-cuts. The whole of the canvas must be covered in the same way, with marks inter-fingering over lines and not stopping at them. Verticals must be composed of hatches too, so that close-up they are blurred but if you stand back the vertical is there.
4 Try hatching over a bright-coloured, say orange, under-painting or coloured substrate. The under-colour twinkles through the hatches, offering a special atmosphere.

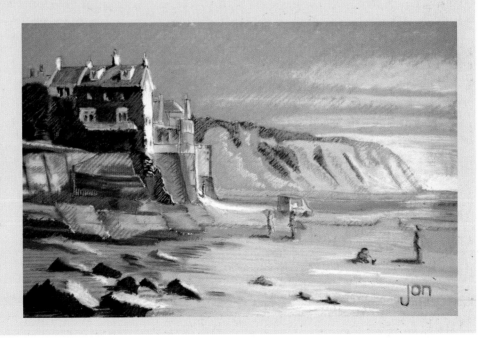

Robin Hood's Bay, on the Yorkshire coast of England. Notice how the hatching binds the image together, offers a pleasing shimmering effect and diminishes the need for detail.

B. HATCHED SPORTS TO INCREASE DYNAMISM

1 Select a sports image – something with splashes like swimming or kayak racing, for example.
2 Sketch, scale-up and paint in a realistic fashion.
3 Add bold, rough hatches using the same colours so as to almost obliterate the realistic subject. Do this in stages so that you do not completely wipe away the reality, but so that the viewer has to study it to work out what it is. Applied to the right subject, this gives a very pleasing effect.

Dragon Racers. This image shows an attempt almost to destroy the dragon racers image, but at the same time to depict the energy and dynamics involved.

EXERCISE 21.

More Use of Texture: Dots and Tesserae

A. DOTS

1 Start with a realistic image or perhaps an abstract-like (from a quirky view-point) one. Do not make the picture too big, as dotting is even more laborious than hatching. Paint it in realistic colours, applying the pigment flat, to act as an under-painting to the dots that are to come.

2 Dot over the top of the under-painting using spectrum opposite colours. This can be tedious work. The end result, however, can be very satisfying and well worth the effort.

Does the end result look dull? Grey? If we have put spectrum opposite on top, the two ought to cancel to some degree.

B. TESSERAE

This exercise emulates tiling with small tiles, like the Romans did two thousand years ago on their floors and walls.

1 Select a simple subject, something as simple as a balloon on a string.

2 Compose and scale it up onto the canvas.
3 Apply the colours in squares of colour. These are your tiles, but try to keep them more or less horizontal, but not geometric (definitely do not do this with a ruler as this will ruin the effect), it must look hand-finished.

Some tiles can be cut in half, but the more disciplined will stick to full tiles so that curves are stepped but will show as curves when we stand back.

4 Leave a gap between the tiles as a single-coloured grout will be added once the tiling is complete.

Car Park. **The dots over a spectrum opposite underpainting do not seem to kill the colours.**

128. *Balloon On a String*. **Very simple, but curiously pleasing.**

Use of the texture of the substrate

The texture of the substrate (the surface or material on which you choose to paint) is extremely important. Indeed, finding the right textured paper can change an artist's whole approach and style.

It is worth shopping around the paper manufacturers to find really textured papers. For other than watercolourists, heavy papers can be gessoed. For pastellists, a mixture of acrylic gesso with pumice powder (very fine volcanic glass bubbles, available from the pharmacy in tubs) mixed in with it can create wonderful textures with the right 'tooth' for pastels.

The use of a really textured substrate can add another dimension to most of the exercises in this book. Broad-brush approaches or the use of the side of the pastel stick work best on textured substrates. For otherwise realistic images, it takes them into a different dimension.

Maryport is an abstracted but figurative painting of the North-West England port, painted in monochrome blues, produced by gently stroking the pastels over the pumice/gesso prepared canvas surface. Atmospheric perspective controls the success or otherwise of this image. Similar effects can be produced in other media using dry-brush techniques.

Maryport. Maryport is an ancient port in North-West England. This image is in monochrome blue and illustrates the importance of substrate texture in developing atmospheric perspective.

Bluebell Wood offers an example of substrate texture and the way it can affect an image.

Golfer. Again a monochrome, using substrate texture.

Hats. There are so many more brain sensors for tone than for intensity. Could this be why monochromes are so pleasing?

EXERCISE 22.

Flattening

Imagine an image as being formed by pieces of card laid down overlapping each other, but showing a definite third dimension. Think of broken glass catching light on its leading edges, for example.

1 In your sketchbook, draw an imaginary bird taking off in flight (find a photograph to help if necessary).

2 Change all curves to straights.

3 Think about tones, and add these with respect to the direction of light. Leading edges will be lightest, and other surfaces will reflect light to differing degrees.

4 Scale-up whilst thinking more about this image being made of stacked-up cards. Your imagination is all important.

5 Add colour from one or two families.

Sketch for *Crane*.

Crane. This image uses dynamics, no curves and a limited palette plus a dash of spectrum opposite. The whole image looks as if it is made up of flat components.

EXERCISE 23.

Positive and Negative Shapes

1 Select a subject that offers positive and negative shapes (perhaps like the deck chairs illustrated at the beginning of this chapter, for example).

2 Sketch, compose and scale-up.

3 Working in a small colour family, colour the positive shapes using flat colour.

4 Give the negative shapes some contouring in order to provide them with more emphasis.

5 If this emphasis becomes too strong, this can be remedied by giving the positives some texture.

Mushrooms. Achieved with a realistic starting point, a limited palette of blues and violets, the emphasis of negative shapes and added texture.

EXERCISE 24.

Symbolism

The *Escape* painting shown here was based on an old stockade at Dedham in Suffolk, England. A photograph was taken in bright sunlight and the posts and their shadows were treated as spectrum opposites. The shapes between were treated in the same way, with contouring to emphasize the negative shapes. A Hundertwasser sky finished off the image (*see* Chapter 6 for more on Hundertwasser).

The footprints going towards the stockade and climbing over it symbolize the breaking of a relationship.

AGEING

The symbolism here is simple, that of growing old.
1 Observe any plant in its prime.
2 Sketch it and imagine it getting older.
3 Have thrusting, brightly coloured shapes and colours at the top and drooping, dull colours at the bottom.

Escape. This makes use of complex spectrum opposites, an emphasis on negative shapes, a Hundertwasser sky and symbolism.

Ageing. At the top of the image are bright, thrusting marks implying the vigour of youth; this subsides to drooping marks at the base, which, along with holes in the leaves, implies age.

MORE ABSTRACT PORTRAITS

John and Julie were getting married and they requested a painting as a wedding gift. They preferred a more abstract approach to a realistic one; the result was the work shown here entitled *John and Julie*.

The combination of caricatured but recognizable faces, linked one to the other, having fun, and drinking champagne with wine glasses and popping corks appealed as representing the day. This approach had broken new ground and led to two more paintings of combined faces. It is based on the Picasso idea of having full-face and profile combined by eyes, nose and mouth. Explore it for yourself.

John and Julie. **This piece involves simplification, caricaturing, spectrum opposites and symbolism.**

What evolved: *'Two more reds please / Wait 'til I get you home'.* **This makes use of violet blues working with green blues, red violets and blue greens, simplification and blurring.**

Passion. **Use of blues and violets with some additional tonal contrast.**

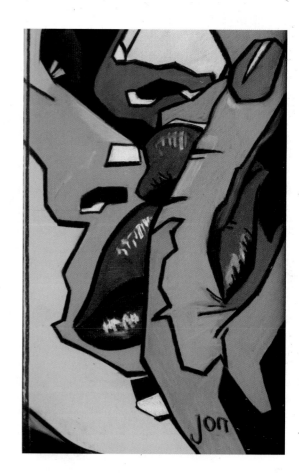

EXERCISE 25.

Simplification of the Figure

When faced with a figure to draw, our first reaction is to become tense and to worry about our ability to reproduce a likeness or a credible copy. We are not creating a likeness, however; we abstractors do not care about such stuff. Relax and have fun.

1 Start with a source image – a photograph, a picture from an advert in a magazine, or a model posing if that is available to you. You are going to reduce this complicated figure into perhaps five curvaceous sweeps of paint. Practise on sheets of old newspaper, because dimension is important here and your sketchbook is probably too cramped for this exercise.

2 Stick your paper to a board. Select a broad brush or a thick pastel. Simplify the form into sweeping lines, but the lines must vary in thickness and use the 'dry-brush' effect when lifting off at the end of a line. Remember we are making free, bold, sweeping marks, not careful, uptight ones. The figure can be represented naked, or clothes can be indicated by elegant sweeps. Work to get a pleasing composition of sweeps. However, there should be no facial features, no buttons, no toenails, and so on.

3 After one or two practices, and when confidence is rising (but before you become stale and over-practised), move to your chosen substrate. Consider your colours, just two together, one for the lines and one for the background. You might try pale orange-yellow on dark orange-red, dark purple on shocking pink, or something more subtle using colours from adjacent families.

4 Practise with several colour combinations, but feel relaxed and free. There will be at least one with which you are pleased.

Simplified Figure. **A figure reduced to a few sinuous lines.**

ABSTRACT LANDSCAPES

Let us start with some basics about landscapes.

There are failsafe ways of painting landscapes, which can be adopted or ignored in abstraction. The two main conventions are that of linear perspective and that of atmospheric perspective. Both attempt to make what is up close look near, and what is distant look far away.

Some artists love linear perspective, but most pay lip service to it whilst not being interested in the technicalities. Luckily for abstractors, linear perspective need not be an important factor. Suffice it to say that things close to you are usually represented as being large, those far away as small.

Roads and tracks are wide close-up and become progressively narrower with distance. The narrowing lines narrow to a point on the horizon – the line between earth and sky – which is toward the top of the picture if you are crouched down, or nearer the bottom if you are viewing from high up.

All lines on roofs come together with distance, so they disappear to so-called 'vanishing points' on the horizon. All vertical

Setting the Stage. Painting the failsafe landscape is like a stage-setting. Divide it into sections, from front to back. Use bright colours to the front and fade them to the back (never use bright colours toward the rear as this causes flattening). Use the darkest darks at the front and gradually paler tones toward the backdrop. Use texture at the front, but never further back. Treat each stage slice entirely differently.

walls disappear to points in the sky if we look up and into the centre of the earth if we look down. It is no more complicated than that.

That is enough on linear perspective for now, but there are more advanced aspects of abstraction when linear perspective can be useful. Do not worry about these now – we will explore them later in Chapter 6.

Similarly, atmospheric perspective is not essential to abstraction, but it is a useful tool to have available. All knowledge is useful, so let us attempt to understand it.

Consider a theatre stage with curtains at the front and a big sheet at the back. Projected or painted on the sheet at the back are distant mountains and sky. Just behind the curtains at the front of the stage is something big and strongly coloured, such as a bush or a treasure chest. Between the front and the back are two or three sections of stage set – perhaps a house and a line of trees. The way a stage is set is a useful way of describing a failsafe approach to atmospheric perspective.

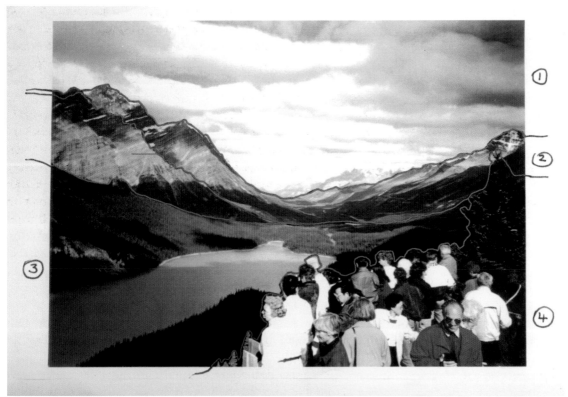

Photograph 1, with possible splits for an abstract landscape indicated.

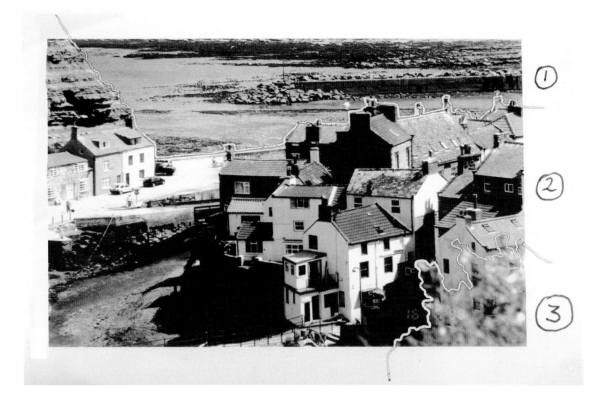

Photograph 2, with possible splits for an abstract landscape indicated.

Every landscape can be sub-divided into foreground and background, with two or three sub-sections in between. In painting, as in stage-setting, each section must be treated differently. The foreground should have the darkest darks and the brightest brights, which should not appear on any other section or the impression of recession is ruined. The backdrop has the most faded and palest chromatics. The stages in between have backward steps from bright to faded and from dark to light.

The same applies to texture; it must recede from the front of the picture to the back. A bush might show leaves in the foreground, for example, but nowhere else. Further away a wood or a forest may take on an outline or it may remain a silhouette.

This is atmospheric perspective. It is as though the air is a filter that diminishes tone and intensity with its thickness. The further away something is, the thicker the air in between, therefore the paler the chromatics should be and the less intense the brightness of the chromatics.

Having gone through these basic elements of landscape painting, let us ignore them completely for now. The most satisfying landscapes are those painted in the mind of the viewer.

Evocative landscapes that do not strictly depict a place, as most of us understand a landscape, but depict a mood (a sense of place, yes, but more importantly an atmosphere that evokes a feeling of nostalgia) seem to be more attractive to the sensitive viewer. It is as if, as a viewer, you are not just looking for a photographic record of a place, the dimension you are seeking is probably in your emotions via memories.

Therefore, just as a portrait benefits if it looks like the person depicted, it can be similarly important for some landscapes to look like the place they represent. Some landscapes are better left with ambiguity, not being too descriptive of the place but with more focus on conveying the time of day, a season, with a capture of light and mood that can be more attractive to the viewer. The importance of ambiguity in an image is a key message in this book.

EXERCISE 26.

The Warm-Up

1 If possible, use a textured foundation for this exercise. An embossed watercolour paper, a textured canvas, or a sheet of the 'furry' pastel paper would be ideal.

2 Divide an A4 sheet into six or eight sections.

3 Using a dry-brush or the side-of-pastel technique, drag colours in various combinations across each section, stacking them a little like a colour swatch. Apply varied pressure and lift-off as you drag.

4 Try your six or eight colour combinations but vary your dry-brush pressure. Try to vary the width of the stripes, too. Blues and violets might be attempted together. Or, more descriptively, a green foreground might be linked to a violet-blue middle and a green-blue upper. This might evoke a seascape, but do not try too hard, just let it happen.

5 Examine your little images. Do some evoke landscapes? Are they are like mini works by Rothko, inviting mental interpretation and involvement?

6 Select one you like and scale it up. Allow yourself one small vertical mark, carefully placed, to imply a building, or perhaps the sail of a ship. That is it, you are done.

Mini Rothkos. Swatch-type examples of colour combinations.

EXERCISE 27.

The Follow-Up: A Panoramic Landscape

1 Now you should make an apparent retrogressive step. Go to the coast or to somewhere with a wide panoramic view. Sketch the landscape and return to the studio.

2 Scale it up to a wide letterbox format.

3 Apply colour using the same technique as the warm-up exercise.

You will appreciate a whole sense of freedom, of appreciation and satisfaction in being able to visually describe a landscape without the need for detail.

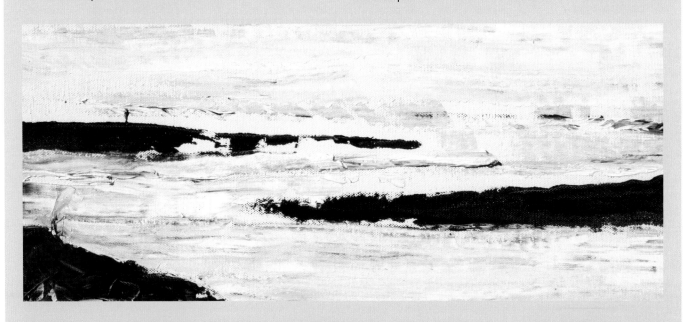

Rocky Shore represents just that, but this was never the intention. With acrylics and a palette knife, these monochromes were spread from one side of the canvas to the other until the paint ran out. One small vertical was added. A rocky shore emerged.

EXERCISE 28.

A Townscape with Blocky Marks and No Detail

This exercise involves depicting a townscape with a broad brush or using the side of a pastel. The approach eliminates the need for detail and concentrates on relative tones, intensities and the sizes of freely made marks.

1 Sketch a townscape with a mind to making it into a vertical letterbox format. Think of looking down a narrow street and out over the town. See the townscape in your mind's eye, not as buildings, but as a series of rectangular shapes sitting comfortably together. There should be no people, no cars and no windows, just blocky shapes, wide in the foreground and getting smaller with distance. Draw it from your imagination if you can, otherwise search for a real source such as a photograph to help you.

2 Compose and scale-up your image into a vertical letterbox format.

3 Add your colour using the broad-brush or side-of-pastel technique. Brightnesses will vary but they may tend toward the faded to dull. Tones will be very important. The darkest darks and brightest brights should be in the foreground, with intensities fading into the distance to the lightest lights – remember this.

This broad-brush technique is wonderful for freeing the mind from the need for detail, and for appreciating that it can be more satisfying to indicate the impression of a townscape or cityscape than to paint it in detail. Get the viewer involved.

A sketch from the imagination to illustrate the exercise.

EXERCISE 29.

Townscapes: Extrapolations and a Limited Palette

This exercise focuses on extending and off-setting lines within the picture. This can be achieved by allowing extensions to pause before appearing again further across the picture and can be most effective when we limit our colour palette.

1 Sketch a section of a townscape showing higgledy-piggledy buildings and roof angles. You may have to search for your source material.

2 Focus in, thinking of the overall composition, so that the final image is not too complex to handle.

3 On your sketch, doodle by selecting key rooflines that might best be extended into other parts of the picture. We are not seeking to slice the image with persistent lines, but instead are selecting a line, and then, perhaps using a ruler, letting it reappear further away. We can do this again and again, but in moderation. This is a game of subtlety. As a variation, a line can be selected and off-set in an en-echelon way. This is a careful, thoughtful process. If it is treated harshly and hurriedly it will not work for you.

4 Having doodled, compose your picture and scale it up to your preferred substrate. Scale-up the buildings and rooflines first and then reconsider the extrapolations in your sketch book in the light of the larger scale. You may wish to adjust them.

5 Now we have to consider how to limit the palette, and in what sector of the colour wheel. Think of what mood we are trying to project to the viewer. You might say to yourself, with all these roof angles we are probably in an old part of the city. Are we to project the sense of age? Perhaps we will use a range of sepia colours. Raw browns rather than burnt (red) browns, for example. If this part of town is lively and vibrant, then why not yellows and oranges? You get the idea: choose your colour family. If in doubt, throw a coin on the colour wheel and just get on with it.

6 Apply your pigment. Worry little about atmospheric perspective – with limited chromatics, you only have intensities and tones to work with. As this is a landscape, keep the bright sides and the shadowed sides of buildings consistent. Use these in a realistic way.

7 Think again as you are painting, about the extrapolations. Are there some lines that line up fortuitously with others? Perhaps offer them a double line, or a line in a different tone. Consider triple lines; this is an image based on lines. Think of off-sets: try not to force them on the image, but carefully introduce them, slightly modifying what is there. Keep on trying out extrapolations. Eventually they will integrate the image and you will know when to stop.

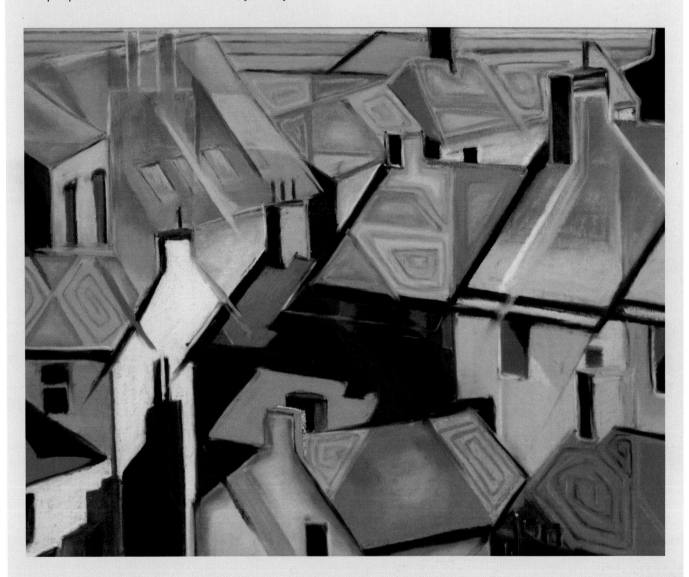

Staithes Roofs. Staithes is an old fishing village on the north-east coast of England. This makes use of a reduced palette, extrapolations and some figuring.

FIGURES IN THE LANDSCAPE

Nothing intrigues people more than people. Whilst some landscapes might benefit from not having people, most, if they have people in them, have added interest.

As indicated in the exercises in this section, figures in the landscape can be indicated beneficially, or even just implied, rather than being drawn properly. Scribbled figures can be much more intriguing than carefully drawn people. Always remember the importance of ambiguity in involving the viewer.

Figure 1: Figures need not be 'well drawn'.

Figure 2.

Figure 3.

Figure 4.

Figures need not be 'well drawn': examples 2–4.

EXERCISE 30.

Abstracting Animals

Groups of animals make wonderful subject matter for abstraction. They form rhythmic repetitions, as the same shapes are seen, often from many angles. Single animals, too, can offer perfect subjects, especially when particularly curvy or angular.

1 Find a photograph of Emperor penguins and select a section to sketch. Draw in the dark heads and feet and put strong, dark lines around the backs and wings.

2 Compose and scale-up onto your chosen substrate.

3 Paint the heads and feet in a dark blue and outline the backs and wings in the same. Select a medium tone of the same blue and apply it to the backs and wings. Chests and abdomens are white, so paint them a bluish off-white. Paint the background a pale blue, which makes the shape of the chests stand out. Add splashes of orange-yellow to the bibs and ear-muffs.

4 Finally, superimpose vertical dry-brush marks in white, dragging the brush from top to bottom each time, to imply falling snow.

Imperial Court. **This makes use of repetition, simplification and spectrum opposites, with drag marks superimposed.**

EXERCISE 31.

Dynamics: Movement in Animals

Repeated shapes, when treated slightly differently, can indicate movement so are very useful when painting animals. This exercise attempts to describe a startled bird.

1 Imagine a large bird with its wings flapping in three different positions – with wings widespread, with wings raised above the body and with them below the body. Long wing-tip feathers are splayed.

2 Sketch the three positions with no respect for ornithological correctness. Draw them as simple silhouettes, without detail.

3 Part-superimpose the three sketches so that one is vertically and part diagonally above the others, pointing in the direction of the beaks, to give the impression of a bird rising.

4 Compose and scale-up. A long vertical axis will suggest vertical movement, whereas the use of a long horizontal axis format will suggest more diagonal movement.

5 Select three different blues or tones of the same blue and paint each bird in its own flat colour. Decide which bird is in front of the other. Apply a dark blue outline using the same dark blue for all three birds. Try to confuse the viewer a little by showing some of the outlines of the bird underneath, showing through the bird above as if it is semi-transparent.

6 Since the bird shapes are all relatively dark, you can emphasize the tonal contrast by placing a white backdrop behind the birds, making it rather like a brightly lit window whilst in effect placing a second frame within the frame of the picture.

A sketch for _Startled_.

7 Surround the white rectangle with a dark violet-blue to further emphasize the tonal contrasts.

8 We now have a strong image made up of tonal contrasts and interesting shapes, but it still needs something else. Work on developing interest in the shapes by contouring the negative shapes. Keep the contours within the blue and violet families. Contours can be angular using sections of straight lines or they can be curved.

9 Let the picture simmer while you decide what else may be necessary.

Startled. **This makes use of a limited palette, superimposition, tonal contrast, frames within frames and dynamism.**

EXERCISE 32.

Geese in Flight: Use of Negative Shapes and Contours

1 Sketch a group of large birds in flight. Draw them simply, as silhouettes, making sure that some of the birds overlap, forming enclosed spaces between the bird shapes.

2 Compose and scale-up.

3 Select a family of colours in which to work.

4 Select a fairly dark tone for the birds and apply the paint flatly, using the same colour for all the birds.

5 Paint the background with a tonal progression from light to dark, from bottom-left to top-right.

6 Add a dark outline around the bird shapes, but where they overlap put the outline around the combined shape and not around each individual bird.

7 Outside the dark outline paint in a pale off-white outline, which, where the bird-shapes overlap, will form an inline around the negative shapes.

8 Create a series of other lines within the negative shapes.

9 Stand back and examine your creation.

Notice that, where the background is pale, the dark outline of the birds stands out. Conversely, where the background is dark it is the pale outline (the inline to the negative shapes) that is prominent. The eye is always drawn to the biggest tonal jump. In this case we have two. Notice too that, because the bird shapes are of flat colour and the negative shapes are more elaborately worked, the eye is drawn to the negative shapes.

Leave the painting for a while so that you can judge if it has enough to satisfy. In the example shown a symbolic 'distance and time' was added to the backdrop.

A sketch of birds in flight.

Migration. This makes use of a limited palette, tonal contrast, and an emphasis of negative versus positive shapes.

EXERCISE 33.

Looking At and Seeing Through

A. OVERLAY AND COLOUR CHANGE

1 Select three simple shapes and lay them on top of each other. Sketch them as if they were all transparent.
2 Scale-up and give each object its own colour. In the example shown, the bottom object is blue, the next is violet and the top one is yellow.
3 Now you should change the tone of each object wherever it is underlain by another. For the example shown, the blue object is blue where nothing overlies it. The violet object is violet where nothing

overlies it or underlies it. In the parts where the blue object underlies it, it goes darker. The yellow object lies on top and sometimes overlies one object and sometimes two. Where it overlies one object it goes a tone darker, from yellow to golden yellow. Where it overlies two objects it changes tone again to become orange.

This exercise is not as complicated to do as it is difficult to explain; have a try for yourself.

TOP LEFT: *Anchor 1.* Colour switches, if done diligently, ought to be acceptable in each version. These were done on computer.

TOP RIGHT: *Anchor 2.*

BOTTOM LEFT: *Anchor 3.*

B. OVERLAY, COLOUR AND TEXTURE CHANGE

1 Select a simple subject, but ensure it is one where some things are in front of others. The aim is to allow the viewer to see what is in front and behind at the same time.
2 Sketch the subject with a substantial proportion of things behind one thing. Show all of what is behind as if what is in front is transparent glass.
3 Scale-up.
4 Add colour, either realistic or otherwise, to what is behind and give it a texture (dots, hatches, or whatever.) Add colour to what is in front as flat colour but where it overlies something ensure the colour of what is behind changes to become noticeably darker and the texture of what is behind is eliminated.

Again, this can be quite difficult to explain, so let us discuss an example. If you have a red apple behind a banana, the apple will show red with spots. Where the banana lies in front of the apple, the apple goes a darker red and loses its spots. If there are also violet grapes behind the banana, they change from violet with spots to a smooth and darker violet. Where there is just background behind the banana, the banana shows a darker tone of the background. It is not as difficult in practice as it sounds, so give it a try.

Organic Farming. **Behind the fence everything has it own colour and some kind of texture. Where the bars of the fence are in front, the objects behind can still be seen, but their colour goes darker and their textures are lost.**

DEVELOPING A SERIES: WORKING ON A THEME

There are occasions when one comes across an interesting subject that seems to offer scope for differing approaches or for a progression or sequence.

Penguins

The penguin series was based on interest in the repeated forms from different angles offered by a large group of Emperor penguins.

The first in the series simplified the shapes almost into hieroglyphics. This developed into attempts to depict the animals in their environment, with more emphasis on weather and temperature. Thereafter the images simply became close-focus and even more simplified, with curves becoming straights and some use of contouring.

Imperial Signifier.

Pre-*Where's the Penguin?* sketch of shapes from *Imperial Signifier*.

The series stopped before losing its figurative connection and becoming completely abstract. The first picture was later pushed into the abstract, making it appear even more like hieroglyphics.

Where's the Penguin?, derived from the bottom-left quadrant of the sketch.

Imperial Crown.

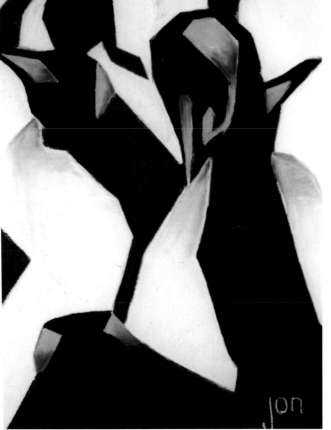

TOP LEFT: *Polar Perpetuity.*

TOP RIGHT: *Simplified Penguins 1.*

BOTTOM LEFT: *Simplified Penguins 2.*

Line drawings

The line drawing series are all figurative, but they focus in and
are all made up of abstract shapes.

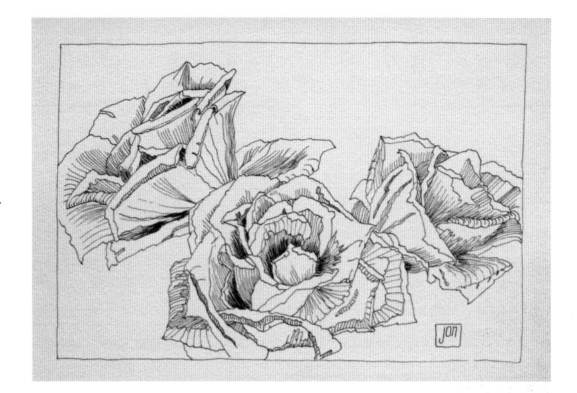

Roses.

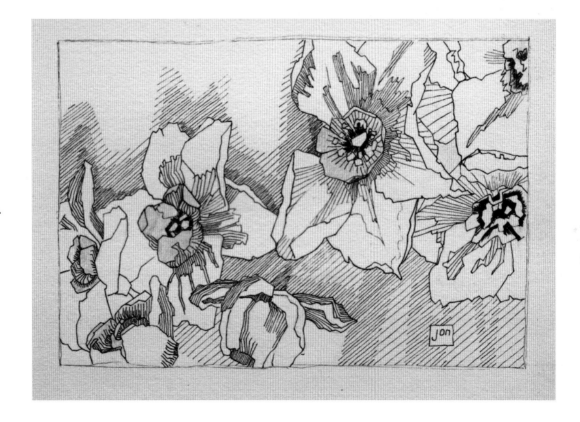

Daffodils.

Rose 2.

Orchid.

Snape.

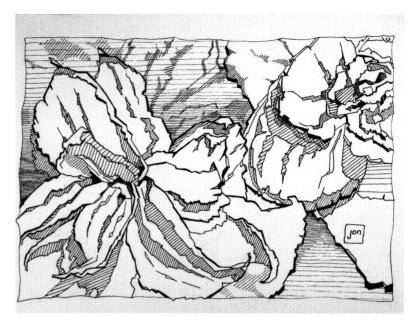

Lily.

Sax.

Another Poppy.

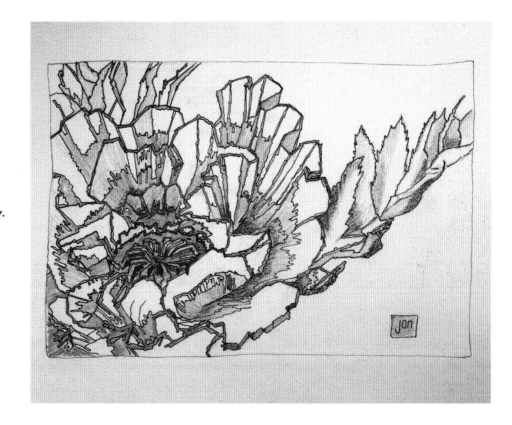

Sailing boats

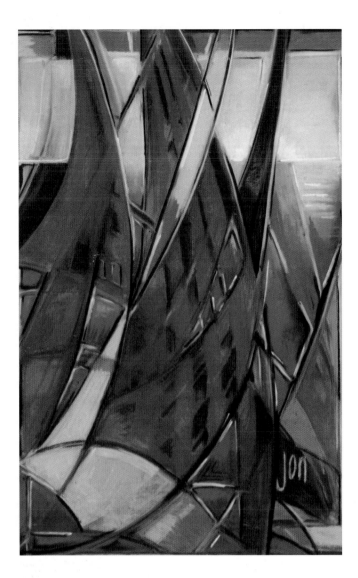

Regatta.

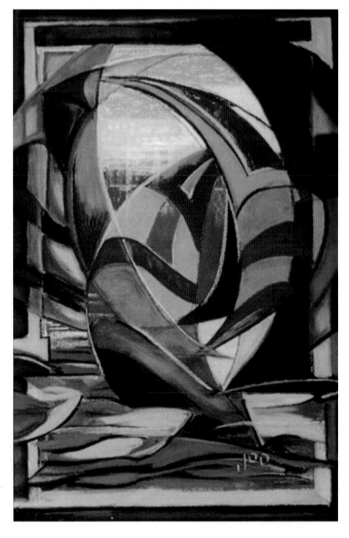

Light Winds.

Morning Mists.

Still Sailing?

Wyvenhoe series

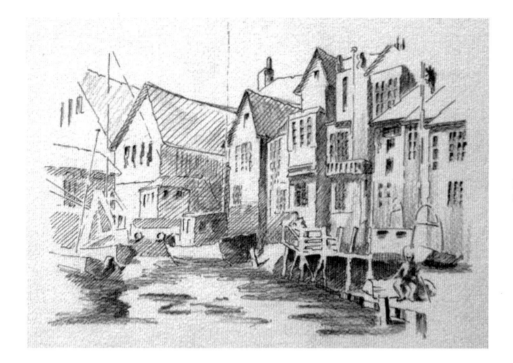

Wyvenhoe ink drawing. Wyvenhoe lies alongside the estuary of the River Colne in Essex, England.

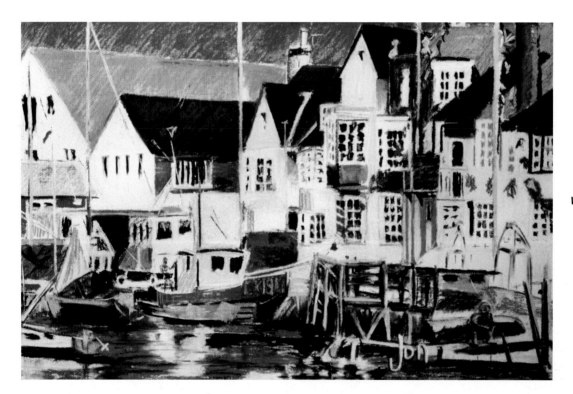

Wyvenhoe, first version.

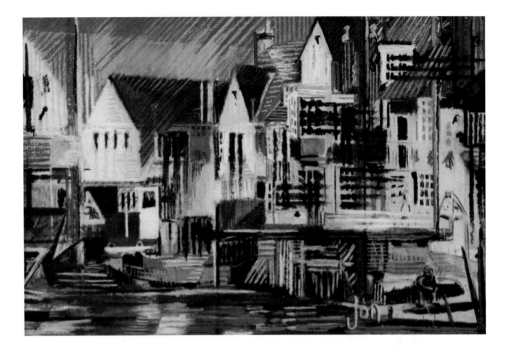

Wyvenhoe, abstracted version.

Musical instruments

The series on musical instruments are close-focus monochromes
based on photos taken from the television.

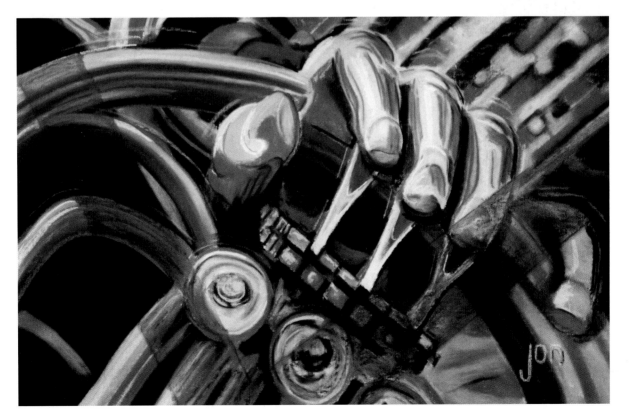

French Horn.

Cello 1.

Cello 2.

MVPs

The MVPs are abstracts that rely on multiple vanishing points.

MVP6.

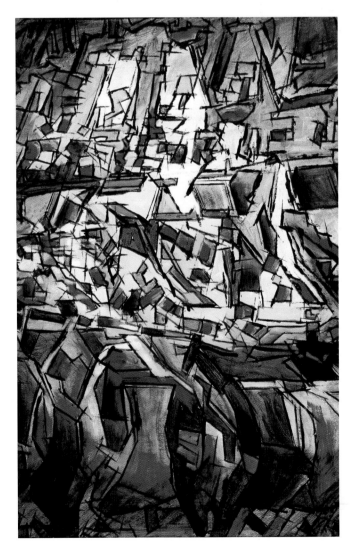

MVP7.

MVP12.

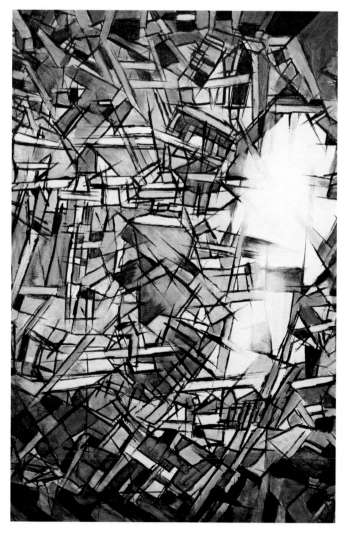

MVP9.

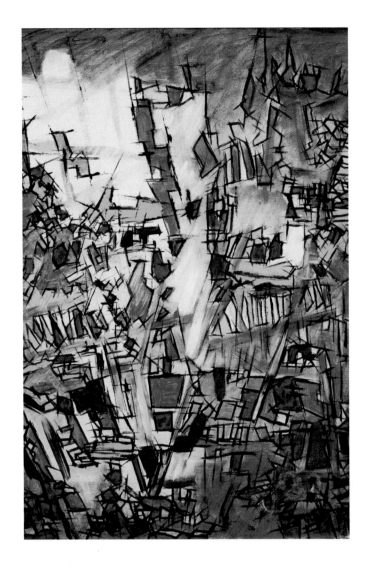

MVP8.

Series of paintings seem to come about for various reasons, sometimes based on subject matter that leads to a series of slightly differing approaches, or sometimes they evolve from an approach that can be applied to different ideas.

MVP11.

THE JOURNEY BACK TO ABSTRACT

This chapter covers a brief history of the return to abstraction and details some of the main participants, the main movements, their aspirations, and what they achieved, along with practical exercises to illustrate the mental steps taken.

STEPS TOWARDS ABSTRACTION

We will take a rapid journey through the second half of the 1800s and into the first two decades of the 1900s, where we will linger a little longer. During this period, through the advancement of technology and thought processes, the arts opened out and took on a new interpretation. We will examine the way technology affected art, the way the accepted mindset allowed art to evolve and the way politics and war affected art.

The whole evolution towards modern abstraction started in the middle 1800s with the emergence of Impressionism and progressed from there.

Impressionism

The accepted way of painting prior to Impressionism was to go through several preparatory stages, ending up with a studio-finished, smooth and blended image, with few marks visible. This approach had been adopted since the Renaissance, so had been established for five hundred years or so. All kinds of mirrors, lenses and gadgets had been invented to help the artists get closer to realism.

OPPOSITE PAGE:
MVP4.

Before the Impressionists, this was how it had to be. The image was to be as we see it, with the emphasis on eye-to-hand representational skills and no involvement of the imagination other than sometimes moving components around to improve the composition.

Subject matter was nearly always to be religious, to be derived from classical mythology, or paintings were to be portraits of the wealthy and influential. There are exceptions to this generality – notably Turner in the later part of his life and much later Courbet, who in the 1850s dared to paint ordinary people, including himself – but, broadly speaking, this was the accepted norm. To err was to risk ridicule and public outrage.

The Impressionists took bold steps at that time (the 1860s) to break away from this established way of working, of subjects painted, and the way they were painted. They were young, in France, needing change and to escape the limitations imposed by the system of representation reinforced by the guilds and insisted upon by the Establishment. They were out to rock the boat – and they did.

Curiously it was the invention of another gadget, the photographic camera, and its coming into general use by the mid-1800s, which allowed artists to take their first steps away from realism. Photography now provided the realism, thereby freeing the artist from this responsibility.

The Impressionists' style of painting was to paint there and then – out in the open with little studio finishing. Marks were left unblended; colours were bright, with spectrum opposites laid alongside each other; subject matter was no longer pretentious. Clearly they had digested Courbet's attitude because, in general, they painted themselves, the artists, doing what they did – and they seem to have been having a good time.

Needless to say, as with any avant-garde, the Establishment

endeavoured to belittle them. However, as always, time prevailed and within a generation the avant-garde became accepted and of course eventually became the Establishment once more. But at the time, the Establishment created many problems for them.

Post-Impressionism

By the 1880s and 1890s the Post-Impressionists had progressed further away from the previous constraints. All had moved away from the perceived need to represent the subject exactly as it was. This was a time for experimentation and mental exploration. Some deliberately drew their subject 'badly'. Some developed styles of mark-making. Some worked on colouration. Mostly, however, the trend was a mixture of these, of trying out different approaches and experimenting with other people's ideas – the realization had arrived that there was no need to paint realistically and a new world of painting and representation was opening up.

The lead-in to Cubism and related movements

The mindset of both society and artists was changing rapidly, and, whilst all the artists involved contributed, we will consider the contribution of two individuals because of what they offer to our progressive learning process here.

HENRI MATISSE AND FAUVISM Matisse had a great investigative mind and was prepared to push art to its limits. Sometimes it is hard to understand the thought processes behind his work – such as in his hand-holding rings of badly painted pink ladies. (We must remember, however, that since these were commissions we do not know how much control he had over them.) At other times, one gains an insight into his level of thinking. Take, for example, his portraits. Here he switches the use of tones, which would usually be realistic, for chromatics. For the time, this was very advanced thinking. He and his friends experimented, especially with colour. Their wild use of colour earned them the nickname of the Fauves, which means 'wild animals'.

EXERCISE 34.

A Matisse Portrait

1 Select a face from a newspaper photograph (one with plenty of light-and-dark contrast).
2 Sketch it, or draw on the photograph, outlining the darkest darks, and the lightest lights and two in-between tones.
3 Compose and scale-up.
4 Add bright chromatics to each delineated area, but not using realistic colours. Instead of using tones that get lighter or darker, change chromatics. For example, a darker tone might become green, a lighter tone violet. We are substituting tones for chromatics.
5 Be free with marks and textures.
6 Select a backdrop to enhance the main subject.

An illustration of results from the Matisse exercise. The lightest lights are shown as red, and darkest darks as yellow. The in-between tones are represented as violet and green.

PAUL CÉZANNE Cézanne was a major influence on what evolved in art. His adopted style of strong directional marks is extremely pleasing to us now but, at the time, it was not accepted by the mainstream. His major contribution to the development of art was that he moved mark-making forward into facet-making, which in turn led to geometric shapes and to Cubism.

More than this, it was he who first painted objects from different angles on one plane, thereby kick-starting the Cubists and moving art on to abstraction. If anyone can be offered individual credit for seeding the re-acceptance of abstraction – painting from the imagination – it is Cézanne.

EXERCISE 35.

A Cézanne/Braque Landscape with Geometric Shapes

A. A HATCHED LANDSCAPE

1 Imagine a landscape that includes buildings on a hillside with rocks and trees. It is a high hillside that stacks from bottom to top with little space for sky in the composition.
2 Sketch the scene in your sketchbook.
3 Scale it up and paint it in realistic colours but use broad overlapping brush marks, rather as Cézanne might have done (but cruder if you can manage that).
4 Stand back and study the results.

B. A GEOMETRIC LANDSCAPE

1 Sketch the same scene again but simplify all realistic shapes to become geometric ones – cylinders, cubes and pyramids. Give this some thought, emphasizing form by having light come from one side to allow lights, darks and in-between tones.
2 Scale-up.
3 Add paint, mainly in the orange-gold-yellow family of colours.

A sketch of a hillside landscape with buildings, trees and rocks in the foreground, painted very crudely in Cézanne-like hatches. With imagination, or by standing back a long way, it is such a landscape.

The same landscape reduced to geometric shapes such as rhombi, triangles, and circles.

Divisionism

Impressionism and its separate marks moved art into an intermediate stage, which some call Divisionism precisely because marks were divided. Whilst the Pointillists dotted their stiff and wooden paintings, most other artists at the time experimented with free mark-making. This was undoubtedly a major step in breaking the mould of how art was to be produced. Examine early Kandinsky paintings that use separate mark-making. Look too at some of Paul Klee's paintings of the late 1920s. (For exercises to develop use of texture see Chapter 2.)

Iberian and African influences (sometimes called Primitivism)

In the early 1900s and during the transition from Post-Impressionism to Cubism there were some other influences in fashion at the time. Artists had been applying their newly found freedoms to the reinterpretation of accepted realistic classics, but it was as if they were at a loss as to where to go next. It was a time for reassessment – what of the old should be kept, and what was the new to be? At the same time Iberian sculptures and African images, especially African masks (which were readily available at that time in Paris), were to influence the development of art.

In particular, we should consider the Paul Cézanne *Female Bathers* painting of 1885, which was reworked by Picasso who applied African masks to transform it into the famous *Les Demoiselles d'Avignon* in 1907. As artists we can see that Picasso, when he started this picture, did not know where he was going. Copying someone else's starting point (which was well accepted at the time) indicates a lack of inspiration. Applying masks badly to Cézanne's picture was not inspired, as masks were all the rage with the avant-garde at the time. He did not complete the work with any technical skill (at this time neither he nor Matisse put much value on the skilful application of pigment) – that was not in vogue with the avant-garde.

Nevertheless, the result is accepted by the art world as a masterpiece. It was not too new, it was not too different at the time, but it became a threshold, a critical step toward Cubism.

MINDSET INFLUENCES

Modernism

Around the turn of the twentieth century a will to amalgamate or to synthesize the arts was seeded, to present the visual with movement, with music and with poetry. Whilst rhythm is common to all of these elements, and pairs can work well together, it is difficult in practice to create a satisfactory union between them all – but this did not prevent this need from prevailing throughout Europe, at least until the mid-twentieth century. The Cubists explored visual depiction in space and time. The Futurists worked on the depiction of movement in painting. Before this the Fauves, with Matisse as their leader, had explored the use of colourful colour. In general, there was a discomfort with what had gone before. In art, literature, poetry, music, photography, the emerging cinema and in architecture there was a broad need to move on to something new and to move together in unity between the arts. There was also a mood of rebellion, of frustration, because everything had been subdued by the Establishment for too long.

This broad philosophy pervaded the world of the Arts and contributed to the emergence of many art groups such as Der Blaue Reiter, Die Brücke, the Suprematists and eventually the Constructivists, all of which emerged in the first decade of the 1900s with the arrival of Cubism and Futurism. (*See* Chapter 2 for more details on individual groups.)

This drive toward a holistic look at the Arts was itself brought about by outside influences such as discoveries in science, the ideas of philosophers studying various aspects of existence and the research of psychologists into what eventually evolved into the science of brain function. Improvements in communications also helped to disseminate this knowledge. Poets such as T.S. Eliot and W.B. Yeats re-thought the way in which poetry was presented. Changes in music also influenced the other arts – Debussy and Schönberg changed the established classical rules of harmony, and jazz was also emerging in the USA. Jazz, with its improvisations, is to music what abstraction is to visual art. The two, jazz and abstract art, emerged in synchronicity and as the result of a radical change in mindset.

Cubism

Cubism is an umbrella term enveloping several concepts and is the next clearly identifiable step in the evolution of modern art. It came about probably because there were many different people involved, all pursuing research into the new unknown of art. Also, the evolution of new ideas was rapid because communications were improving, so one approach led to another over very few years.

It is worth considering some aspects covered by Cubism as they are pertinent to the progression of abstraction. Within Cubism certain concepts are accepted. Consider the following:

- The artist has taken full control of the image produced.
- Previously accepted methods, approaches and conventions are ignored.
- Realistic portrayal is mostly spurned.
- The need to copy is rejected.
- The use of the imagination comes to the fore (because copying is rejected).
- Form and shapes are simplified from the realistic and are reduced to geometrical shapes. (This allows some to link man and other animals with machines.)
- Objects are viewed from different angles and are presented together on one plane.
- By presenting multiple viewpoints together there are also multiple perspectives on the one plane.
- Space and time are flattened by the three different dimensions being presented together as two. (In case you are puzzled, time is flattened because the viewing of all the aspects portrayed cannot be done at the same time in practice, but they are presented in that way on the canvas.)
- Subjects are merged with the background with linear extrapolations forming links.

- Subject matter is simple and everyday – such as Braque's musical instruments, bottles and drinks, people, and so on.
- The palette is often limited, with a focus on the use of neutrals rather than brights (although in other cases brights are developed).

Realistic clues or symbols are placed in the image, which might otherwise be unfathomable. It was almost as if the Cubists were a little afraid of taking that final step into abstraction. We should sympathize with this as, at the time, they were being very brave and were suffering enormous criticism from the Establishment.

GALLERY/MONTMARTRE CUBISM: BRAQUE, PICASSO, GRIS The early Cubism of Braque and Picasso is sometimes called Analytical Cubism because they reduced the role of colourful colour by painting in neutrals and they broke the image into many facets based on what they observed in the subject. Importantly, they also observed the subject from several viewpoints and painted them all on the same plane with links to each other and to the background.

EXERCISE 36.

The Cubist Approach to the Multiple Viewpoint

The first sketch shows the selection of three different views of an object with curves removed.

1 Select a simple object such as a cup.
2 Sketch it from three different angles.
3 Superimpose the sketches as though each object is transparent, so that all parts of each object are visible even where they overlap.
4 Remove all curves by resolving them into a series of straights.
5 Compose and scale-up.
6 Add colour, giving each image its own set of colours but decide on colour changes where the images overlap.
7 Turn on an imaginary lamp to one side and see the shapes as a set of lights and shades based on this. Bring out the third dimension.
8 Doodle with the outline, perhaps adding texture.

Beware of starbursts. Often, in this type of image, several lines converge on one spot, which tends to catch the eye and draws attention to a point that may not deserve the added emphasis. Try to spot starbursts early in the evolution of the picture and solve the problem simply by moving some of the lines away from the centre of the star.

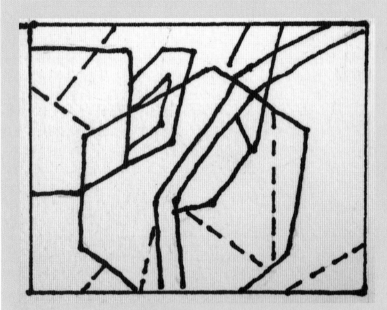

The second sketch shows the three viewpoints merged and cropped.

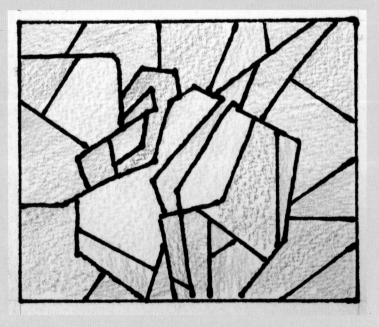

The third sketch shows a more advanced stage, with some lines removed selectively and others moved slightly to avoid starbursts. The next stage might be to doodle further and to create more 3D shapes such as pyramids.

THE SALON CUBISTS: METZINGER, GLEIZES, LEGER, THE VILLON-DUCHAMP BROTHERS The Salon Cubists also worked in Paris but they had little to do with Braque and Picasso. They were much taken by the idea of man and other animals becoming machine-like. People at the time were overwhelmed with the power of machines, the importance of engineering and of new dimensions and scopes in architecture. By 1909 Fernand Leger, who earlier had worked as an architectural draughtsman, was depicting figures as being built up of a series of box-like shapes along with tubes, cones, funnels, discs and spheres, so that some called his style 'Tubism'.

In the 1890s and early 1900s time-lapse photography had been demonstrated to the public, who could now see how a horse galloped (for example) by breaking the rapid movement into a sequence of photographic images. This technological breakthrough strongly influenced artists of the time, notably Marcel Duchamp (who painted his famous *Nude Descending a Staircase* in 1914) and the Futurists who were dedicated to portraying movement and dynamism.

EXERCISE 37.
Salon Cubists' Tubular Figures

An action sketch of tubular sporting figures.

1 Select a group of figures from a newspaper
 photograph – people involved in sport, for example.
2 Sketch the figures, converting the limbs, torso and
 heads to tubular or circular forms. Hands and feet
 can become ovals and digits can be sausage-like.
3 Scale-up.
4 Decide the direction from where the strongest light
 is coming and add colour, painting the limbs and
 bodies in varying tones of blue-greys, emphasizing
 form to make the 'tubes' appear metallic.

5 Having painted the neutrals (the blue-greys), think
 about contrasting these dulls with brights. Sports
 clothing, for example, can be painted very brightly, and
 the crowd in the background can be represented as
 multi-coloured circles with blurred edges so as to make
 them recede.
6 Decide if the composition needs more. For example,
 if it is a picture depicting a very dynamic sport would
 detached sections of certain tubes help portray this?

SYNTHETIC CUBISM Braque and Picasso moved on to collage, sticking patterned materials alongside pieces of photograph or newspaper text and linking components using paint. Collage made the Cubists' work easier. With this method components of the image can be jiggled and adjusted on the table top until juxtapositions are pleasing. You then stick the bits down and add links through the image using paint. Varnish on top and there you have it. Do try it: it is not as easy as it reads.

EXERCISE 38.

Cubist Collage

1 Choose a theme, such as musical instruments, sports
 equipment, a good night out, or whatever. Seek out
 five or six photos from magazines along these lines,
 with some coloured and some black and white.
2 Cut them out and arrange them on your substrate
 so that they create a satisfying relationship, image
 against image and colour against monochrome. Add
 at least one un-themed element – a piece of wallpaper,
 perhaps.
3 Stick them with glue onto the substrate.
4 Select linear or curving elements from within the
 components of the image to extend and to link the
 component parts to a satisfying degree.
5 Make these links using paint or pen, or whatever you
 feel appropriate.
6 Go through the consideration process. Modify,
 consider, then varnish.

A collage of images cut from newspaper colour
supplements.

THE PURISTS: OZENFANT AND JEANNERET In the years approaching the 1920s and in the early 1920s Ozenfant and Jeanneret wrote in learned architectural and art journals that they thought Cubism had lost all discipline and needed to be brought to order. They proposed Purism. They maintained the Montmartre subdued colours and limited palette, they liked their subject matter of geometric, mainly man-made objects (such as bottles, vases and jugs) and they painted them in a well-drawn fashion, mainly with flat colour with the shapes often interlocking, with the negative shape of one object becoming the positive shape of the adjacent.

Images in this vein were painted over seven or eight years, but in many ways they were retrogressing and they left no avenues to develop. The Purists painted themselves into a mental corner, so the approach fizzled out. It would seem that their architectural background somewhat stifled their art and imagination. Ozenfant continued in art, both painting and teaching in France, England and the USA. Jeanneret went on to become better known as the world-famous architect, Le Corbusier.

EXERCISE 39.

Purist Still Life

First, a note. Of course it is of interest to study the works of previous artists and do please look them up on the Internet. However, remember that, as far as these exercises are concerned, it is not our intention to copy their work. It is more important, having analysed what our predecessors were doing, to follow the exercise without reference to their work so that we can build the mental lessons into each personal practice. We are not trying to copy them, we are trying to understand their thought processes. The aim is to give you something to build on, not to get you to paint like them.

An interpretative sketch of the Purist still life exercise.

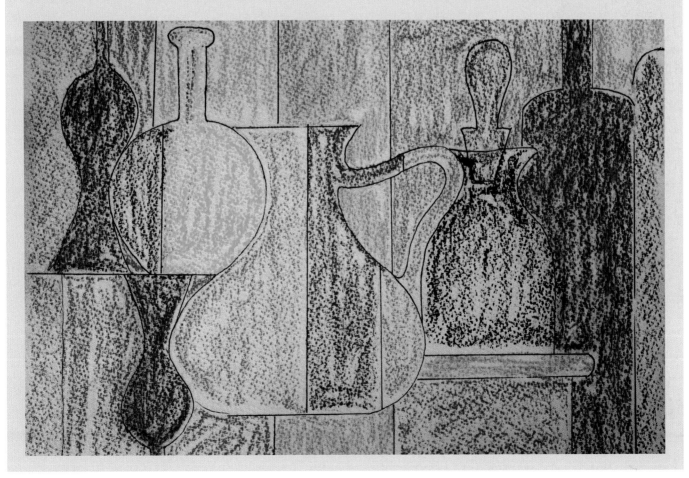

1 In your sketchbook, start by sketching a curvaceous jug with a curved spout and a curved handle. Draw it carefully and symmetrically.

2 Create a mental store of different wine bottles and glasses, of more jugs, vases and jars. Even have a store of curved musical instruments, perhaps a guitar or a saxophone.

3 Fit other objects around the original jug. Use a selection of large objects and small objects and not all on the same level, like on a tabletop, be prepared to stack the objects. Be content to change your scale – a small guitar might just fit that gap between the bottles, for example. If you run out of curves, build up on straights.

4 Compose and scale-up.

5 Select a palette of generally dull colours of varying tones using just three segments of the colour wheel.

6 Add colour to the objects with each shape having one chromatic and one tone, applied flatly.

7 Adjust the colours until you are satisfied with the juxtapositions. Can more be added by increasing tonal contrast? You could darken some of the darks, for example.

8 Is the picture too dull for your taste? If so, select a bright colour to use as a fine outline around some or all of the shapes to give the image a lift. Ozenfant and Jeanneret would not have approved of brights in the 1920s but they both developed a better understanding for bright colours, especially related to architecture, later in their lives.

The Futurists: Time-lapse painting to convey movement

The Futurist movement in Italy was not a direct offshoot of Cubism, but it did result from the same need for change that precipitated Cubism. The main artists involved were Marinetti, Severini, Balla, Boccioni, Carrà and Russolo. There is a wonderful photograph of them together that shows them looking more like bank managers than artists.

This image could not be further from the truth. They were, in fact, radical thinkers and were very outspoken. They were anarchists. Their manifestos are quite shocking to read, even today. They wanted the old art out, and they supported violence, war, speed and machines, and, more generally, change and movement. Marinetti was a writer, who eventually became embroiled in politics, but Futurism was affecting music, literature, architecture and film by the 1920s and 1930s. In the pre-First World War phase, Futurism, joined to Cubism, strongly influenced Russian artists. By the outbreak of war in 1914 the factions of Futurism had fallen out and the core of the movement ceased to exist, but the influence of Futurism outside art still rolls on.

EXERCISE 40.

A Futurist Figure on the Stairs

This is an exercise based on the Marcel Duchamp painting *Nude Descending a Staircase*, a perfect example of Futurism, but of course Duchamp was not a Futurist. He was, however, influenced by the same advancement of technology at that time.

1 Sketch a simple set of stairs in profile. Put it low in your sketch.

2 Imagine a figure ascending the stairs, step by step. Sketch the figure as it would appear on each step. Draw it roughly – this is not a life drawing, it is a rough sketch. If you wish, make the figure a tubular figure, as in a previous exercise. Duplicate and triplicate lines on the trailing side to suggest movement, in the manner of illustrators of comic magazines.

3 Crop your sketch to contain no more than five stairs.

4 Scale-up.

5 Select a small family of colours that are not realistic – greens, or blues and violets, or yellows, golds and oranges to browns.

6 Select a dark colour, complementary to the family selected, to act as an outline. Line will influence this image strongly.

7 Treat the figure on each step differently as it moves up the stairs. The figure at the bottom of the stairs should be given the thickest lines and the darkest tones. The figure on the highest stair should be given

the thinnest lines and the palest tones. The figures in between should show a progression between the two. Use the line duplication and triplication technique as used in your sketch.

8 Darken the tones beneath the stairs and also throughout the opposite top corner of the painting. We are trying to contain the light to emphasize the diagonal downward movement.

9 Allow time to study what you have created and to make final adjustments.

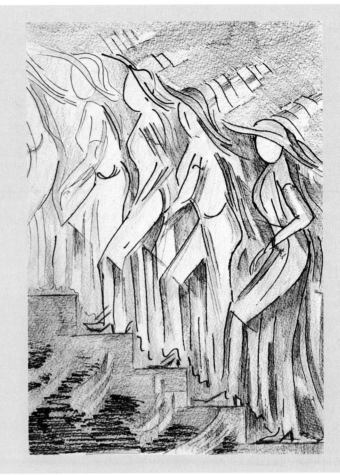

This sketch illustrates a figure climbing the stairs in a loose time-lapse fashion.

Try applying a similar technique to the following subjects:

- Birds in flight
- Dogs racing
- Boats bobbing
- Vehicles rushing
- Dancers

THE FINAL STEP INTO COMPLETE ABSTRACTION

Whilst all the movements in art were subjected to similar influences, they all took on different aspects according to the personalities involved. All were in some kind of communication with others, so no group worked in isolation. All of the art groups of the early 1900s were involved in the evolution of abstraction, but seven artists (and probably more) of the time took art from realism, through the abstracted but still figurative, to abstraction. These were Piet Mondrian, Natalya Goncharova and Mikhail Larionov (working together), Kazimir Malevich, Paul Klee, Vassily Kandinsky and František Kupka.

Complete abstraction was a logical end-point to an evolutionary trend. It was another critical threshold that allowed art to move on. The arrival of art at this end-point now allows us, as artists, to decide where, within this scope, we want to paint. This book endeavours to demonstrate that there are attractions to painting between the realistic and the abstract. The middle ground is at least as fruitful as the two end-points, and probably more so as it offers more scope for mental flexibility.

Piet Mondrian

Mondrian was a more than competent realistic painter of landscapes. Dutch by birth, he was educated in art in Amsterdam and he exhibited in Paris in 1911. He moved to Paris soon after this, and absorbed influences from Divisionism, Fauvism and Cubism, but he adopted Cubism in his own way.

He returned to Holland on holiday in the summer of 1914 and when war broke out in the August was unable to return

to Paris until it was over, in 1919. During the war he undertook much reflection on the issue of emotional versus spiritual representation and his images became progressively simpler in colour, texture and use of shape, moving through a chequer board phase to his familiar squares and rectangles and use of flat red, blue, yellow, white and grey with black lines by 1919.

By this stage, his paintings were abstract and he returned to Paris. Although he talked and wrote about dynamism, plasticity, and rhythm, in reducing the image to a flat composition he engages the viewer by demonstrating that imbalances in shapes can be made comfortable with the careful positioning of his blocks of colour of differing visual 'weights'. In 1938, with another war looming, Mondrian left Paris for London and then after two years moved on to New York, where he died in 1944.

Mondrian had always been interested in links between painting and music, but he continued his rectilinear mental puzzles through to his last famous *Broadway Boogie Woogie*, painted in 1943. Whilst undeniably abstract, this image represents the view down to Manhattan from the Empire State Building or some similar high-rise, and implies the artist comfortably re-linking his abstraction with representationalism.

Mondrian progressively simplified landscapes, trees and the sea to become a series of vertical and horizontal lines. His friend, artist Theo van Doesburg, argued that this was too wooden and lacked dynamism and that diagonals were necessary, but Mondrian persisted. At first, these lines formed square shapes, like a chequer board, which was neither interesting nor involving to the viewer. The next stage was to create shapes of varying sizes and various proportions. Now things became more involving. He varied the thicknesses of lines and made some into double and triple lines. Even more interesting. But black lines on a white ground need more to be art. Mondrian applied colour: yellow, red, blue and grey. The square and rectangular shapes may not have created a comfortable composition, but the application of flat colour could put this right. Balance was the solution. Using the various weights of the colours and their juxtapositions, a work of art could be produced. This is what Mondrian's later paintings are about: composition and visual balance.

EXERCISE 41.

Neo-Plasticism Exercise: Shapes Related to Visual Colour Weights

1 Using a pencil in your sketchbook, create a composition made up of vertical and horizontal lines. You have, say, nine lines, which can be varied in thickness or duplicated. Keep it simple.
2 Doodle, trying various compositions.
3 When you have a composition you feel is more or less acceptable, think about adding colour.
4 Try using hatching in various directions as a shorthand for colour. You are using tone as a temporary substitute for chromatics.
5 Scale-up.
6 Paint your lines in black or dark blue.
7 Work out in your mind which of your colour choices represents the hatching of the sketch. Is the blue you have chosen heavier than the red and yellow, for example? Use grey to create the subtle balance.

No doubt there will be an element of trial and error to this exercise, as it is not easy.

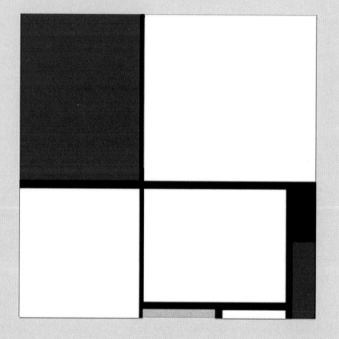

Mondrian-style 1, produced on the computer.

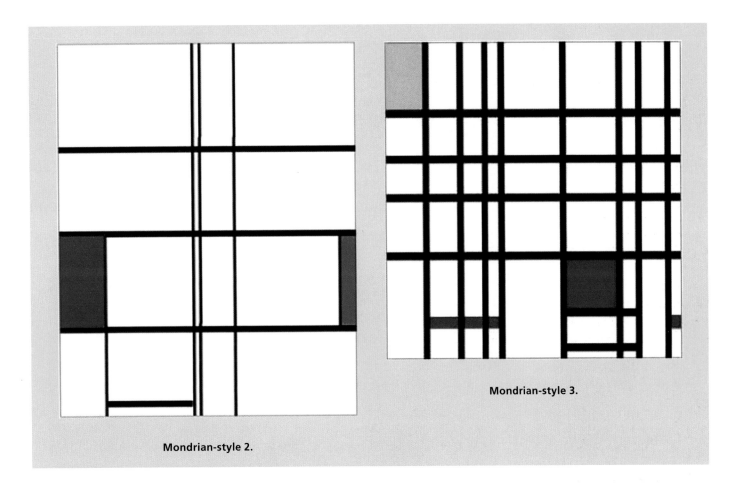

Mondrian-style 3.

Mondrian-style 2.

Natalya Goncharova

Goncharova was born in 1881 and studied mainly sculpture at Moscow Academy of Art but returned to painting in 1904. Much influenced by Russian folk art, later by Cubism and more so by Futurism, she became a major force in the Russian art avant-garde of the time. She was a member of Der Blaue Reiter from the beginning in 1911, and exhibited with them in 1912 in Munich. The famous Donkey's Tail Exhibition in Russia was held in the same year. With her husband, Mikhail Larionov, she developed Rayism, which took Cubism and Futurism into the complete abstract.

Having achieved this she returned to the practicalities of earning a living, as she had important contacts with Sergei Diaghilev and Igor Stravinsky. She designed costumes and sets for Diaghilev's *Ballets Russes*. This brought her to live in Paris where she died in 1962, having adopted French nationality in 1939.

Mikhail Larionov

Larionov was born near Odessa in 1881. He studied art at the Moscow School of Painting, Sculpture and Architecture from

1898 and taught there upon graduation. He was fired from the school in 1912 for organizing a demonstration against teaching methods. He had met Natalya Goncharova back in 1900 and they lived together for the rest of their lives. He was very much involved with the Post-Impressionists, putting on an exhibition in Moscow that included Matisse, Gaugin, Derain, Braque and van Gogh.

Larionov created the Jack of Diamonds art group and the Donkey's Tail group between 1909 and 1912, and in 1913 he created Rayism (Rayonism), which was amongst Russia's first abstract art movements. This movement painted rays of light reflected from objects, creating interplays of line and colour where they intersect. The stimulus for this came from the invention of ray-gum in Moscow in 1912, which was used in photography to create radiating, broken fragments. Rayism was abandoned after a year or so as the war intervened.

Larionov was badly wounded in the war and was left with limited concentration. In 1915 he left Russia to tour with th[e] *Ballets Russes* and in 1918 he settled in Paris in order to wc[rk] for Russian ballet creator Sergei Diaghilev as a designer of se[ts] and as manager of Natalya Goncharova. He suffered a stroke in 1950 and died in Paris in poverty in 1964.

EXERCISE 42.

A Rayist Sunflower

The sunflower is something of a halfway stage, having a seed-head made up of diamonds, and pointed petals.

1 Starting in your sketchbook, compose the huge sunflower head in the top-left corner and spilling out of the picture.

2 Make the seed-head and petals deliberately into geometric diamond shapes, sub-divided into triangles.

3 The rest of the composition should be made up of plant stem, leaves and the plant pot, which, in an angular image, cannot be round.

4 Extend some of the radiating lines present in the sunflower head out into the bottom section of the picture, just as lines at first to get the feeling of the composition. Into these radiating lines then feed the stem of the plant and the leaves.

5 Consider splitting the elements in this lower section, breaking things up with dislocations.

6 Doodle with this, then scale-up.

7 Add colour as realistic colours, spectrum opposites or switches around the wheel.

8 Add line to the edges to the degree that pleases you.

9 Study your picture for some time before completing and framing.

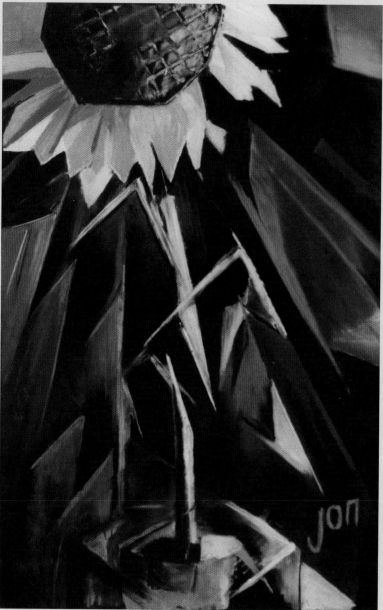

Sunflower. **This makes use of tonal contrast along with brightness contrast, straight lines and dislocations.**

EXERCISE 43.

A Rayist Cockerel

Imagine an aggressive cockerel, with its beak moving, the jagged comb on its head moving and the feathers on its wings all of a quiver. All the shapes are pointed, so this should make an interesting subject for a Rayist-style painting.

1 Visualize this raging rooster as more close-up than you would comfortably want to be – in other words, focus in closely on him.

2 In your sketchbook think of him filling the page and beyond, and, using needle-like triangles, sketch the feathers, beak and claws using double and triple lines to imply lots of movement. We still want the image to be abstracted so do not be too figurative. We do not need an eye, for example.

3 Scale-up.

4 The image should not become too figurative so it is better not to use realistic colours. Try painting this rooster in blue-greens and green-blues. If he is to be dark, have some light background from the same colour family and vice versa.

5 Keep tones realistic, using a single light source. We do not want to play too many games at the same time. Ask yourself regarding the acicular shapes you have created, do they need a dark or light edge at one side or the other? Not all perhaps, but would the image benefit from some such subtleties? Try varying tones, with darker ones at the pointed end of each shape and light at the other, for example. Or the other way round.

6 Apply your mind. Is the image too obviously a cockerel? If so take it back so that it is barely discernible. If it is lost, then that is fine, but mention the cockerel in the title.

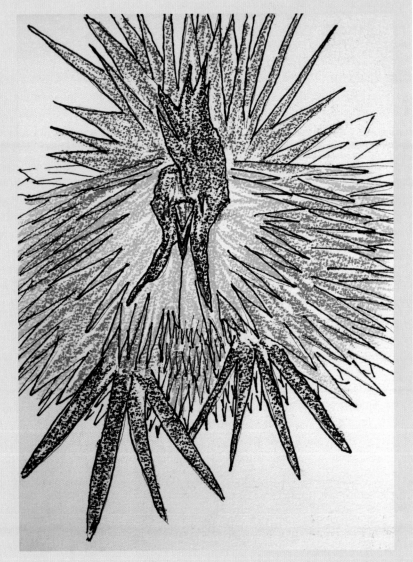

A sketch depicting a rooster in a Rayist manner.

Kazimir Malevich

Malevich was born in Kiev, Russia, of Polish parents (Malewicz) in 1878. He studied art in Kiev and later (1904–11) in Moscow. He was much influenced by Cubism and perhaps more by Futurism.

Suddenly, it seemed, but having given it considerable thought, Malevich announced his promotion of Suprematism in 1913, 'freeing art from the burden of representationalism', and he wrote a manifesto in 1915 in which he stressed the need to paint feelings rather than things. He painted a series of geometric paintings consisting mainly of rectangular shapes and lines using colour and a degree of overlaying of shapes and linear perspective, conveying the impression of the third dimension. He said that these were founded on air photographs but they are clearly cerebral abstract paintings and in no way influenced by copying anything.

His paintings evolved ever simpler until in 1915 he produced *Black Square on White*, and, finally, a *White Square on White* series, which were exactly how the titles describe them. The square, he said, represents feeling and the backdrop the void beyond feeling. At this stage, after a period of five years, Malevich decided that Suprematism had run its course.

The Russian Revolution of October 1917 initially boosted the Russian art world with high hopes of improvements following the removal of the Tzar and his family. But Malevich seemed to sense a different mood. He returned to painting Futurist and figurative paintings and taught art in Vitebsk (where he became director of Vitebsk Popular Art), Petrograd, Kiev and Leningrad.

In 1927 Malevich took his Suprematist work on a tour through Warsaw, Berlin and Munich, which brought him his deserved international recognition as one of the first abstractors. He contrived not to take his unsold paintings back to Russia, which implies that he had forebodings. Well-founded forebodings it turns out, because, with the death of Lenin and the demise of Trotsky, Stalin had taken over the Communist Party in 1922 and art became progressively stifled. By 1935 it was completely politicized.

In 1930, because of his associations with German artists, Malevich was arrested and imprisoned for two months. Abstraction was no longer accepted. He was criticized for rejecting the good and the pure, for rejecting a love of life and of nature. To his great credit, Malevich fought back, arguing that art must progress for its own sake and is nothing to do with politics or peoples.

He died in near poverty in 1935, and the city of Leningrad offered a pension to his wife and daughter. In 2008 *Suprematist Composition*, painted in 1916, sold for $60,000,000 in New York.

EXERCISE 44.

The Malevich Exercise: Suprematism

1 Cut out several shapes in coloured paper or card. These could be rectangles, tapered rectangles, squares, circles and triangles of various sizes. Have some thin lines available, too.
2 Assemble these on a coloured rectangular or square backdrop.
3 Assemble the shapes to produce the concept of space, with distance disappearing into infinity.

Think about what you are producing. Is it painting emotions or is it playing with the positioning of shapes mechanically? (*See* the illustration on page 6.)

Paul Klee

Klee was born in 1879 near Bern in Switzerland. His mother was Swiss and his father was German, which meant that Paul was a German national under Swiss law. Both parents were musicians and Paul learned the violin at seven years old. By the age of ten he was playing in a respected orchestra. As a teenager he also displayed drawing skills and in 1898 he went to Munich to learn art, attending the Munich Academy two years later. He graduated with a degree in Fine Art and had his first solo exhibition in Bern, after which it moved on to three other Swiss cities.

In 1911 Klee met August Macke, Vassily Kandinsky and other artists from the New Munich Society of Artists, which included Gabrielle Münter, Alexei Jawlensky and Marianne von Werefkin. He was particularly friendly with Franz Marc.

In 1911 they exhibited in Munich as the Blaue Reiter group. In 1912 he travelled to Paris where he met some of the Cubists who impressed him greatly. He always admitted that he did not understand colour, but in 1914 he went to Tunisia with August Macke and Louis Moilliet where at Kairouan he came to terms with colour. *Style of Kairouan* was made up of roughly rectangular blocks of colour and some circular shapes and many musicians have commented on its parallels with music. These blocks of colour became his building blocks.

Soon after this, the First World War began. Friends Macke and Marc volunteered to serve their country and were later killed. Klee stayed in Munich and painted. When called up in 1916 (on the day he learned of Franz Marc's death) string-pulling by his father helped him avoid the front line and he continued painting, achieving sales success as well as public acclaim.

After the war Klee wanted to teach, so he was very pleased to receive the invitation of Walter Gropius in 1920 to teach at the Bauhaus, where he worked until 1931. His paintings continued to sell well and he developed his colour theory and philosophy on art. In 1922 Kandinsky joined the staff of the Bauhaus and, in 1923, along with Lyonel Feininger and Alexei Jawlensky, they formed the Blaue Vier. In 1925 they toured the USA, teaching and exhibiting.

It is true to say that Klee was never very happy during his time at the Bauhaus. He was somewhat aloof and found it difficult to identify with his students. There were always conflicts with the practical crafts element of the Bauhaus and the increasing swing towards architecture and connections to industry, which left art sidelined. In the late 1920s it was taken off the official curriculum altogether – although Klee and Kandinsky were allowed to be heads of extra-curricular art departments. Klee was not happy with this and in 1929 approached Dusseldorf Art Academy in search of a job.

From 1931 to 1933 Klee was teaching at the Dusseldorf Academy, until a Nazi publication denounced him as a 'Galician Jew'. It is hard to know now what this meant, but the insinuations put him on the wrong side of German feeling at the time, on both the Spanish Civil War and on attitudes to the Jewish race (with the Second Word War fermenting in the background all the while). Despite there being no truth in the description, the Academy fired him. He took this very badly, and returned with his family to live in Switzerland.

Klee had exhibitions in London and Paris in 1933 and 1934 and met Picasso. In 1933 he first showed symptoms of scleroderma, which finally killed him in 1940. During this period he was probably at his most prolific, peaking by painting more than 1,200 works in 1939. At least this is what people say, but can anyone paint more than three paintings a day, every day, for a year? Apparently so.

In 1938 Steinway Pianos produced the 'Paul Klee Series' of 500 pianos to acknowledge Klee's musical links in his paintings. The Swiss government finally gave Klee his Swiss nationality, six days after his death. In June 2005 the Zentrum Paul Klee was opened in Bern, Switzerland, displaying over 4,000 of his works.

Paul Klee painted in many media and on many substrates, and even invented his own media. He was a witty man who was dedicated to painting 'the reality that is behind visible things', so sought motifs, symbols and metaphors to make this visible. Many of these motifs were clearly derived from the diatoms, plankton and other micro-organisms emerging from the scientific research of the time.

Klee ventured into complete abstraction, but he was happier with surreal symbols and some contact with the figurative. He was also very philosophical within his talks at the Bauhaus, discussing art's links with movement, language and music, often leaving his students struggling. If he himself struggled to put his message over, then it will be difficult for someone else to explain his philosophy and how it applied to and affected his paintings, because his teaching forced his painting along. We are left therefore to analyse what he was offering, in practical terms, to art.

EXERCISE 45.

Paul Klee Building Blocks

Klee offered a lot more to art than his building blocks, but we should look at this aspect of his work. All exercises involve composition, but this will concentrate on harmony. The shapes progress, but so do the chromatics.

1 In your sketchbook, stack a series of hand-drawn rough rectangles, with around a dozen in the sketch (or a lot more if you prefer). Long, thin ones or a mixture of shapes. They can be long-thin in a vertical direction, or horizontal – you choose. Build up the blocks in a free manner, varying the sizes of the blocks so that you are not producing a brick wall, but encourage the verticals and horizontals to take progressive steps in one direction or the other.

2 Scale-up the sketch and think about colour. This is an exercise in harmony, so think about the family of colour in which to paint. Are they harmonious lights to darks or brights to dulls? You choose.

A sketch based on Paul Klee's painting *Highways and Byways* of 1929.

EXERCISE 46.

A Klee Townscape

1 Start as before, with a series of hand-drawn rectangles.

2 Add triangles with a mind to implying a townscape with gable ends. Doodle with it until you are satisfied.

3 Scale-up.

4 Add harmonious but bright colours.

Musical people may find they can include musical elements in the composition.

A sketch based on Paul Klee's painting *The Temple District of Pert* of 1928.

EXERCISE 47.

More Paul Klee building blocks

1 In your sketchbook, build up an image of horizontal rough rectangles, all stacked up but rather randomly.

2 Scale-up with the idea of representing a sunrise.

3 Add colour so that shapes progressively change colour from bottom to top.

Just think sunrise. Klee did not add arcs, but would superimposed arcs improve the effect?

A sketch to illustrate sunrise over water in a Klee fashion.

Vassily Kandinsky

Kandinsky was born in Moscow in 1866 to wealthy parents and he learned to play the cello and piano as a child. Music was always important to him and as an artist he claimed to hear music from a visual image. At the age of twenty he enrolled in Moscow University where he studied law and economics. On graduating he taught in the Faculty of Law. He was a successful teacher who philosophized on spirituality. In 1896 Kandinsky gave up law and went to Munich where he studied art.

From 1903 to around 1910 Kandinsky's paintings demonstrate Post-Impressionist influences with bold brush marks and Divisionist tendencies. He painted mainly landscapes and scenes from Russian folklore.

Kandinsky's first abstraction, created in 1910, consists of squiggles in pen and ink along with splodges in watercolour. This earns a lot more points for courage than for artistic ability displayed. He insisted that the starting point when painting abstracts is the artist's soul, which stimulates his senses to produce the painting. This in itself was an important breakthrough for art. His paintings are thereby spiritual, and he painted music and emotion.

In 1911 Kandinsky formed Der Blaue Reiter group with Gabrielle Münter (his wife in all but ceremony), Auguste Macke, Alexei Jawlensky, Franz Marc, Natalya Goncharova and Paul Klee, and they produced their first exhibition in Munich that year. The following year they, along with composer Arnold Schönberg, contributed to a Blue Rider almanac.

During the next few years Kandinsky painted prolifically, exhibiting all over Europe. When the First World War was declared in 1914 he was forced to return to Russia, where the revolution was threatening. This parted him from Gabrielle. He taught art at two respected centres for art, but found himself out of step with the Russian avant-garde and the authorities so that when Walter Gropius of the Bauhaus in Germany offered him a teaching job he accepted and left for Weimar in 1922.

Kandinsky taught at the Bauhaus through the period of its move to Dessau and on until it was closed by Nazi authorities in 1933. During this period he painted hundreds of paintings and exhibited all over Europe and in the USA. He also wrote books postulating his theories on spiritual art. The Nazis confiscated over fifty of his paintings and destroyed them as 'degenerate art'. He and his wife then moved to Paris where he continued to paint until his death in 1944.

Kandinsky was a great intellectual driven by a need to theorize everything to do with art. He had an insatiable creative drive, which he called his 'inner necessity'. His theorizing led him to take the mental step from painting the figurative to painting the spiritual and abstract.

Vassily Kandinsky painted his emotions, or so he said, but others of us, if we cannot 'read' them, will not identify with the emotions. Whether these emotions transfer to the viewer or not depends on the viewer. He had his own language of the interpretation of shapes and colours which, unfortunately, cannot be accepted universally. His approaches and concepts are now dated. His philosophy and ideas of psychology have been left behind by research that has progressed our understanding.

On the other hand, future research may prove that Kandinsky was on to something exciting. Work in recent years on the so-called Mozart Effect – the fact that listening to Mozart music for ten minutes can improve results for IQ tests on spatial reasoning (the orientation of shapes in space), at least in the short term – does indicate that music can somehow make the right brain more receptive to spatial reasoning. This seems to have been involved in Kandinsky's field of research in a broad sense. The links between certain music and the arrangement of shapes do appear to be confirmed.

Music, as part of the arts and creativity, might be expected to be a straightforward right-brain function, but apparently this is not so. Components, or 'building blocks' to use the jargon, are apparently founded in left and right brains and in the cerebellum. This would explain why music can exist as a right-brain emotion stimulator, but also as a left-brain set of symbols representing music. Kandinsky expected to symbolize visual art in the same way as music. Perhaps this will be possible in the future, but it would appear to be contrary to our understanding of brain function.

Inviting others to describe their emotions visually becomes dangerous ground. Exercises based on Kandinsky's approach therefore become difficult to conduct. The painting of emotions can be done with some agreement as to symbolism (the signs, shapes, colours and marks to indicate anger, peace, frustration, and so on) but in reality love lost and bereavement makes this an approach that experience has shown is best avoided in teaching practice.

EXERCISE 48.

The Kandinsky Orchestral Piece

Kandinsky paints symbols that seem to float in space, in the main, but in a space comfortably within his picture frame. He is telling us that this composition is to be judged on its own and is unrelated to anything else outside the frame.

Without involving ourselves in his claims to be painting emotions from his soul, Kandinsky is in fact juggling with the orientation of shapes in space, so he was decades ahead of his time. This is in the sense that, whilst shapes in space were always part of what art was about, this has only in recent decades become part of psychological/brain function research. Kandinsky had, in fact, reduced his art down to composition and little else.

For this exercise let us choose a Kandinsky subject, that of music, and let us try to paint a piece of classical music, using symbols and in a Kandinsky way, without attempting to copy him directly. Let us just play with shapes in space.

An orchestral piece of music usually progresses through time, developing a theme and passing it between the groups in the orchestra, perhaps ending in a crescendo. Use your imagination to depict this visually.

1 There are different musical sections involved, including strings, woodwinds, horns and drums. In your sketchbook codify these into symbols, trying not to be too literal. Have some symbols for music in your armoury, too.

2 Sketch how a musical performance progresses with quiet phases, loud phases and with the theme passing between the various groups. Just use one symbol to signify a group of musicians, otherwise it will get too busy.

3 Pull the whole together into a composition from introduction to finale. Carefully demonstrate the progression of the music and its passage between types of instruments.

4 Scale-up.

5 Paint the symbols, perhaps on a yellow background, and throw in some Kandinsky arcs and radiating lines where gaps in the composition occur. Or perhaps insert a well-placed circle in moody blue. You could use dark lines, golds and oranges, with carefully placed spectrum opposites, all within the frame, with a respectable gap between symbols and the mount.

This exercise is one of basic composition, of getting the various shapes to work well within the designated space. These are fundamental aspects of art, so they cannot be easy to digest at a thinking level, but nor can they be easy to put into action. Do not despair, as your brain is set up to do this. Persist.

A sketch depicting three orchestral movements in a Kandinsky style.

EXERCISE 49.

A Kandinsky Variation on the Theme of Music: Jazz

Exercises on spatial understanding, in other words understanding composition, are fundamental to art.

1 As with the previous exercise, sketch a series of component symbols representing jazz music (for example, drums, cymbals, horns, keyboards and woodwind instruments).

2 Jazz consists of a tune, a theme or a riff that is passed between players and varied each time, and perhaps at the conclusion of the piece it comes back to the original tune. Try to represent this passing on, with variation each time, visually.

3 Jazz is usually a night-time thing, and conjures up images of dimly lit, smoky bars. You could therefore create a dark blue background with shiny musical instruments emerging from the gloom and with a progression of the music from bottom-left to top-right. Make it symbolic, not realistic.

A sketch depicting jazz.

František Kupka

Frank Kupka was born in eastern Bohemia, now the Czech Republic, in 1871. He studied art in Prague, Vienna and Paris, settling in Paris in 1894. There he worked as an illustrator of books and as a satirical cartoonist for newspapers and magazines.

In 1906 Kupka moved to Puteau, a suburb of Paris, and in the same year he exhibited in the Salon d'Automne. He knew many of the Cubist artists in Paris, although he felt more affinity with the Futurists and was most interested himself in portraying movement. Even so, he resisted association with any art group.

In 1909 his painting *Piano Keyboard/Lake* indicated Kupka's first mental step away from realism and showed an obvious influence by Divisionism. In the next couple of years he developed his ideas on movement, on colour theory (he developed colour wheels, fashionable at the time), and on the relationship between colourful Cubism and music, which became known as Orphism (a relationship he denied), a branch of Cubism. In 1912 he exhibited in the Salon des Independants and in 1913 he published a book in Prague called *Creation in the Plastic Arts*.

The decade of the 1920s was dedicated by Kupka to abstract work with wood-cut engraving, producing impressive and powerful works in black and white. In 1931 he was a founder member of the group Abstraction-Creation and in 1936 he took part in the 'Cubism and Modern Art' exhibition in the Museum of Modern Art, New York, followed by an exhibition at the Jeu de Paume in Paris with fellow Czech Alphonse Mucha. During the 1940s and 50s he exhibited in Prague, Paris and in New York. He died in 1957 in Paris.

Frank Kupka's contribution to art is generally underestimated. He was a free spirit, aware of what was going on in the art world around him, but he remained determined to plough his own furrow. He was analytical and technical, but without the spiritual approach of Kandinsky or the mechanical/design approach of Malevich.

EXERCISE 50.

Kupka Exercises: Dislocations, Verticals and Diagonals

1 In your sketchbook, draw horizontal bands annotated to indicate colour or texture using directional hatching and cross-hatching, as indicated in the illustration.

2 Divide the image in your sketchbook into vertical strips.

3 *Either* mentally dislocate each strip vertically, producing a second sketch that causes the horizontal bands to take progressive but irregular

steps up and down the image *or* physically slice the page into the vertical strips with scissors and manually adjust the dislocations until you are happy with the patterns formed.

4 Scale-up to full size and decide on colour and texture for the hatched areas in the sketch.

5 Add colour and texture, and select a suitable background.

A sketch in monochrome after the fashion of Kupka's woodprints.

An example of the result of the 'vertical slices' exercise.

EXERCISE 51.

An Abstract Figure Using Slabs of Unrealistic Colour and Colour Contouring

1 Find an image of a suitable figure or figures from a newspaper and separate out four or five different tones, stepping from light to dark, by drawing around each tone.

2 Scale-up and add unrealistic colour to each tonal area as flat colour.

3 Rather like a series of halos, contour around the figure with three or four coloured outlines.

A sketch of a seated lady inspired by Kupka's figure studies.

All of the complete abstractors endeavoured to amalgamate visual and aural art. All worked on the integration of music to visual art. All were much taken by Cubism and Futurism, so all worked on movement in visual art. All were great thinkers. All were responsible for moving art back from copying to art from the imagination.

AFTER THE INVENTION OF MODERN ABSTRACTION

It is hoped that this chapter has shown that the return to abstraction and its further development, was not a simple step, but was as a result of an international will for change, a need to move on in all ways of research. Art was just one part of this surge. The early 1900s were such an exciting period of reform, of the rethinking of standards and ways of consideration. By the 1920s complete abstraction had been achieved but, of course, its evolution did not stop there.

Modernism had been established and its drive was not to be denied. In the mid-1920s, Surrealism was born. In the 1930s, Maria-Helena Vieira da Silva was developing what evolved into her unique multi-perspective abstract paintings. By the late 1940s, Fritz Hundertwasser was displaying his own unique take on abstraction and he re-enforced Austria as a leader in the world of art. Having arrived in the USA in 1913, Modern Art built on the experience of the European movements and developed Abstract Expressionism in new ways. By the years that followed the Second World War the focal point for art had moved away from Paris and into New York City.

We have experienced a move from Modernism to Post-Modernism from the mid-1970s until now, in the twenty-first century we have moved into an 'ism' yet to be named – but post Post-Modernism will still do for now. The world of art and the Arts will never stop searching for the new and the different.

In this final section we will look at the work of three artists: Hundertwasser, Vieira da Silva and Diebenkorn, taking us through the mid-1900s and almost to the turn of the twenty-first century. This represents only a taster of the developments of this period but it is a worthwhile journey.

Hundertwasser

Friedrich Stowasser was born in 1928 in Vienna. He grew up through hard times during the Second World War as a Jew, but somehow he and his mother survived. He loved art but did not fit with formal teaching and proved that he did not need it. He developed his own flamboyant style and use of bright colour, and was something of a character, changing his name at will. Hundertwasser was the one he stuck with from the age of twenty-one. He survived in post-war Paris by borrowing from friends. People wanted to buy his paintings but he refused to sell them cheaply as he could live by sponging and felt he did not need the money. Eventually this approach pushed prices so high that he was prepared to sell. His style of abstracted art resulted from an evolution in Vienna that did not follow the trends in the rest of Europe.

The founder of this evolutionary trend was Gustav Klimt, a traditional painter of great reknown. He moved into elaborate motif in the design of dresses to cover up portraits of his naked wealthy clients. This way husbands did not know that their wives had been painted naked. Egon Schiele built on the motifs and ribbons of Klimt whilst pursuing the naked ladies approach of the master.

Hundertwasser was more influenced by the work of Klimt and Schiele than by other early twentieth-century art movements. He believed, wrongly, that there were no straight lines in nature, so he included no straight lines in his work.

Austrian art developed in its own way through Hundertwasser. He became a Gaudi-like architect, re-facing ugly buildings and designing 'green' buildings. Famous as an architect, perhaps more so than as an artist, he died on the QEII in 2000 and was buried in his chosen country of New Zealand.

EXERCISE 52.

Hundertwasser: Ribbons in the Landscape

Hundertwasser built on Klimt's use of motif and ornamentation. He loved wavy ribbons, concentric circular shapes, concentric spirals, lollipop trees, contours, rain drops and onion-domed tops to towers – all painted very freehand in bright colours. If you are not familiar with his paintings then find some on the Internet and spend some time studying them.

1 Start by imagining you are up in the sky in a hot air balloon, with at least one other balloon not far ahead and featuring strongly in the picture. You are looking down and into the distance where there are mountains and a wavy sky. Down below are fields with differently coloured crops, houses, trees and roads forming a patchwork.
2 Sketch this and decide on the ornamentation for each shape.
3 Scale-up and paint in bright colours. Relax, have fun.

A sketch to illustrate the ribbons-in-the-landscape Hundertwasser exercise.

EXERCISE 53.

Hundertwasser: Three Men in a Boat

1 Imagine you are looking down from a bridge over a river at a boat passing a few metres below. There are three people in the boat, one of whom might be rowing.

2 Sketch what you see in your mind's eye. Consider the waves in the water, especially the bow waves and how people might be seen from above as rounded shapes.

3 Scale-up and paint. Devise yourself a colour switch.

A sketch of three men in a boat.

Maria-Helena Vieira da Silva and the MVPs

The Multiple Vanishing Point series of paintings evolved from a study of the work of Maria-Helena Vieira da Silva, an artist of Portuguese origin who became stateless before being offered French citizenship.

Maria-Helena Vieira da Silva was born in Lisbon in 1908. At the age of three, her father, an economist and diplomat, died, and she and her mother lived with her wealthy grandfather. She had private tutors, which led to a rather introverted upbringing, but she was very involved with drawing and painting and with music. She studied sculpture at the Academy of Art in Lisbon and at nineteen years old she and her mother moved to Paris where she studied art under several well-known artists.

At twenty-two years old she married a Hungarian artist, Arpad Szenes, but in doing so she lost her Portuguese nationality and the authorities refused to reinstate it. The couple continued to live in Paris and to have moderate success with their painting. In 1940, they decided to evade the Second World War by leaving for Brazil as stateless persons. In Rio de Janeiro they had modest success with exhibitions, but resorted to teaching to help out. In 1947 they returned to Paris, where Maria began to be very successful with exhibitions all over Europe. In 1956 she and her husband were granted French citizenship and from then on she became amazingly successful, gaining four major honours from the French state, ending with the Legion of Honour. She died in Paris in 1992.

The key to da Silva's art is her original study of linear perspective and her almost diagrammatic portrayal of it. She was obviously influenced by Cubism, although not contemporaneously, but, rather like Mondrian, she ran with it in her own way. She worked on linear perspective and multiple perspectives in the same image to wonderful effect.

EXERCISE 54.

Early da Silva

1. In your sketchbook draw a grid of perhaps twelve squares horizontally by eight squares vertically (or fewer if you prefer). Put it into the top third of the page, as in the sketch shown here, leaving lots of space so that you can build out from the grid.

2. Look at the grid as if it was the end of a room and draw in perspective lines to each corner.

3. Cover the walls, ceiling and floor in squares following the normal rules of perspective.

4. Doodle with these squares, rubbing out some and adding additional perspective lines, contrary to the ones based on the 'end wall'. The sketches show some ideas.

5. Experiment with this until you have a feel for the scope of this approach.

6. Scale-up.

7. Add line by hand, possibly using a fine felt-tipped pen.

8. Add colour to the 'tiles' using blue-greys with touches of ochres, oranges and reds. Let each tile vary in colour from its neighbour.

9. Adjust lines by doubling and tripling the thicknesses in some parts.

A sketch of a basic grid.

Development of the grid.

A third development.

The first sketch here shows the basic grid. There follows a series of sketches building on the grid and moving it towards several vanishing points. Then some sections of lines are removed, allowing the creation of tunnels, steps and pyramids. The final sketch shown is only a starting point, as lines can be doubled and tripled and colours need to be added.

The final sketch.

EXERCISE 55.

More Advanced MVP images

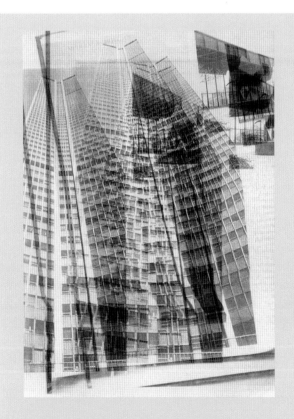

An illustration of a double-photocopy image of high-rise buildings.

An illustration showing the outlining of tones on the photocopy.

1 Find a photograph of a high-rise building or buildings showing lots of perspective.

2 Photocopy it to get a fairly pale, black-and-white copy. Turn the paper around and superimpose another copy on the first, but from the opposite direction so that the two sets of buildings show two vanishing points, as in the illustration.

3 With a fine felt-tipped pen, draw around every little shape and each different tone, not caring what the shapes represent. This is time-consuming, but worth the effort. Eventually you end up with a complex image, as in the illustration.

4 Examine what you have and select an area that you like, showing the shapes streaming away to the two vanishing points.

5 An outlined sketch like the one shown could produce ten or twelve paintings, so use 'L' shapes to allow you to crop a composition from all this potential.

6 Scale it up, marking darks, intermediates and lights.

7 Doodle with perspectives as in the exercise above. The shapes can begin to look as if they are viewed from the air or as if they are disappearing down a tunnel in some parts. Use of consistent light and dark sides to the shapes can add to the three-dimensional effects.

8 Having got the feeling offered by the tones, add colour or paint in a small family of colours.

9 Add fine lines around the shapes.

MVP3. An example of a result of this exercise.

Richard Diebenkorn and Landscapes

Richard Diebenkorn trained in art at San Francisco's California School of Fine Arts (where he taught after graduation) immediately after the Second World War, when he left the armed services. Throughout his life he swung between figurative and abstract painting. He is most famous for his Ocean Park Series of abstracted landscapes, which he started in 1966 when he moved to Los Angeles. Over the following twenty-five years he painted 140 of these glowing abstracts composed mainly of vertical and horizontal sections but, like Maria-Helena da Silva, he added confusing and intriguing linear perspective shifts. He died in 1993 aged seventy. He has still not received the worldwide acclaim that his contribution to art deserves.

EXERCISE 56.

A Richard Diebenkorn Landscape

This exercise is based on Diebenkorn's Ocean Park Series.

1 Orientate your sketchbook with long axis vertical. Take a ruler and draw up to five or more horizontal lines, but in order to indicate distance do this in the top quarter of the page. Imply that they are getting closer together nearer the top of the page to emphasize the landscape/perspective impression.

2 Study the horizontal slices and decide which deserves a vertical. Select one and place it carefully one third in from the left-hand side.

3 See this short vertical line as the corner to a huge room and draw perspective lines out to the left-hand side implying that the wall is coming forward.

4 Where a line makes contact with one of the horizontals, stop it so that it appears to run parallel to the back wall but is closer to the viewer.

5 From key points on the horizontals, drop three verticals. Stop the horizontals where they contact the verticals. By now your sketch should give the feeling of linear perspective, but not a realistic one as some bits are confusing for a landscape and perhaps follow the rules for buildings.

6 Put in another diagonal contradicting the perspective given by the 'wall'.

7 Scale up. It is best to use a textured substrate (although Diebenkorn did not) and select a family of generally pale, neutral colours. On the other hand, you might choose to go for brights if you wish. Add colour, using subtle changes between the horizontal and vertical sections.

8 Be prepared to adjust your colours. Decide whether you want lines to show, or otherwise just use edge.

Diebenkorn's paintings were subtle and sensitive, but yours need not give the same effect.

A Diebenkorn-style landscape: a sketch of the early stage (based on *Ocean Park 67*).

A Diebenkorn-style landscape: The final sketch with colour (based on *Ocean Park 67*).

Here we end our journey through the redevelopment of abstract art. Modern abstract art obviously follows different concepts to those used by our prehistoric ancestors, but we cannot be sure in what way. Our ancestors of a hundred thousand years ago, although not of our time, were otherwise just like us. They had no motor cars, no flying machines and no computers, but shared the same fundamental human experience. In producing their images they were communicating with their contemporaries, just as we do now. Nothing changes, yet everything changes.

INDEX

OTHER ART BOOKS FROM CROWOOD